THREE YOUNG RATS

AND OTHER RHYMES

ALEXANDER CALDER

EDITED AND WITH AN INTRODUCTION BY
JAMES J. SWEENEY

DOVER PUBLICATIONS, INC.
MINEOLA, NEW YORK

Bibliographical Note

Three Young Rats and Other Rhymes, first published in 2010, is an unabridged republication of the work (second edition) published by the Museum of Modern Art, New York, in 1946. The original edition was published by Curt Valentin, New York, in 1944.

International Standard Book Number

ISBN-13: 978-0-486-47536-3
ISBN-10: 0-486-47536-0

Manufactured in the United States by Courier Corporation
47536001
www.doverpublications.com

Introduction

Psametichus wishing to learn what was the original language of man, shut up two infants where the language of man was never heard. On being brought before the king they said *bekos* (toast). —HERODOTUS, ii, 2.

Consil Agelastus, Grandfather to Crassus, never laught but once in his life, and that was to see a mare eat thistles ... —THOMAS NASHE: *Have with you to Saffron-Walden.*

Anno 1670, not far from Cyrencester, was an Apparition. Being demanded, whether a good spirit or a bad? returned no answer, but disappeared with a curious Perfume and a most melodious Twang. Mr. W. Lillie believes it was a Fairie.

—JOHN AUBREY: *Miscellanies.*

A SLEIGHT-OF-HAND ARTIST, a friend of mine who earns his living as a drawing-room entertainer, once told me that the most difficult gathering to deceive is one of children. In his own phrase, they are the least distractable. They concentrate on the fundamentals of the problem before them. They do not allow their attention to be carried away by the patter of the magician, or their eye to be seduced by inconsequential gestures. Intensity of focus is the child's gift. Adults are easier victims through their wider, more superficial curiosity.

AGAIN, the child has a near-sighted eye for detail, both psychological and physical. The child is closer to the carpet, to the ground—to the primitive—than the adult. In making a drawing the child goes straight to those features it considers most interesting. The rest is omitted or drastically subordinated. And because the child's inhibitions are limited, it observes few reticences. Its interests are the larger realities of life and death as it conceives them. It views them with a natural hardness of heart that society has not yet taught it to disguise. It lives intimately with nature and sees nature's phenomena clearly; but it is wise enough not to imagine it understands them. It relishes the mystery of the clearly-seen but only half-understood. It thinks by image. And it takes mischievous pleasure in contriving out of these images incongruous associations that often have the quality of fresh and startling metaphors.

LOGICALLY, then, the rhymes and stories which will have the most authentic, natural appeal for children will follow these same lines. This is the case with the traditional nursery songs and tales. Unfortunately children's literature in the present century is in great part the inheritor of the Evangelical "Happy Home" and "Family Altar" attitude of nineteenth century England,—those days when even a royal banquet in the popular mind took the color of tender domesticity ascribed to it in the ballad:

> *The Queen she kept high festival in Windsor's lordly hall,*
> *And round her sat the garter'd knights, and ermined nobles all;*
> *There drank the valiant Wellington, there fed the wary Peel,*
> *And at the bottom of the board Prince Albert carved the veal.*

> *'What pantler, ho! remove the cloth! Ho! cellarer, the wine,*
> *And bid the royal nurse bring in the hope of Brunswick's line!'*
> *Then rose with one tumultuous shout the band of British peers,*
> *'God bless her Sacred Majesty! Let's see the little dears!'* [1]

When the Prince Consort's pious usefulness was celebrated in the *Ballad of Queen Victoria's Baby* ending with the lines:

> *Now has the Queen recovered, and Albert's the nurse,*
> *He puts on the child's napkins, and don't give one curse.*

And publications such as *The Young Lady's Book, The Victorian Sunday School,* the *Penny Day School,* were supplying their youthful readers a related provender:

> *Who fed me from her gentle breast,*
> *And hush'd me in her arms to rest,*
> *And on my cheek sweet kisses press'd?*
> > *My mother.*

> *When sleep forsook my open eye,*
> *Who was it sung sweet lullaby,*
> *And soothed me that I should not cry?*
> > *My mother.*

The direct descendant of this attitude today is the "marmalade-is-nicer-when-its-very-thickly-spread" school of nursery rhymes:

> *James James*
> *Morrison Morrison*
> *Weatherby George Dupree*
> *Took great*
> *Care of his Mother,*
> *Though he was only three . . .*

It is apparently still felt that verses of this character are more edifying to the growing child than the natural savagery and unmitigated child-nightmare tone of such a classic as:

> *My mother has killed me,*
> *My father is eating me,*
> *My brothers and sisters sit under the table*
> *Picking up my bones,*
> *And they bury them under the cold marble stones.*

BUT already in the first half of the nineteenth century Sir Walter Scott was lamenting how much the instructors of our children were losing

by rejecting the venerable relics of nursery, traditional literature, and substituting in their place the present, cold, unimaginative—I had almost said, unnatural—prosaic good-boy stories. In the latter case, their minds are, as it were, put into stocks, like their feet at dancing school, and the moral always consists in good conduct being crowned with success. Truth is, I would not give one tear shed over Little Red Riding Hood *for all the benefit to be derived from a hundred stories of* Jemmy Goodchild. *I think the selfish tendencies will be soon enough acquired in this arithmetical age; and that, to make the higher class of character, our own wild fictions —like our own simple music—will have more effect in awaking the fancy and elevating the disposition, than the colder and more elaborate compositions of modern authors and composers.*

vii

AND in our day Mr. Arthur Waley has pointed out in his preface to *The Way and its Power* that,

For hundreds of millenia Man was what we call 'primitive'; he has attempted to be civilized only (as regards Europe) in the last few centuries. During an overwhelmingly great proportion of his history he has sacrificed, been engrossed in omens, attempted to control the wind and rain by magic. We who do none of these things can hardly be said to represent normal man, but rather a very specialized and perhaps very unstable branch-development. In each of us under the thinnest possible veneer of homo industrialis, *lie endless strata of barbarity. Any attempt to deal with ourselves on the supposition that what shows on the surface represents more than the mere top-mast of modern man, is doomed to failure.*

AND in these early strata lie the roots of some of the best known traditional nursery rhymes and tales. This is possibly why they have such a persistent attraction for the child—through its kinship with the primitive. In fact, it has been suggested that much of the children's pleasure in nursery tales may "arise from an unconscious sympathy between the child and the thought and custom of the childhood of civilization"[2]

IT may be a relic of cannibalism in a rhyme such as "My mother has killed me," or the even better known verses,

> *Fee, Fie, Fo, Fum!*
> *I smell the blood of an Englishman . . .*

It may be a reminder of the practice of human sacrifice as in the child's game "London Bridge is broken down," concerned throughout with the capture of a victim, and its accompanying rhyme,

> *How shall we build it up again?*
> *With a gay lady.*

AMONG primitive peoples it was a common practice to sacrifice living beings as a propitiation to the spirits of the earth or the water at the foundation of a dwelling or a bridge. Human victims were buried beneath the

gates of Mandalay. In Polynesia, the central pillar of an island temple was planted upon the body of a man.[3] Legend tells that St. Columba found it necessary to bury St. Oran alive beneath the foundation of his monastery, to propitiate the spirits of the soil who destroyed each night what had been built during the day.[4] There are several folk songs current among the peasantry of Greece which relate the burial alive of a woman as a sacrifice at the building of a bridge. One, from the Peloponnesos, relates that when the bridge across the Tricha was being built it fell down each night, until a bird perched on its arch and sang a song which told the builders that the bridge could never be built until the wife of the master mason was buried in its foundations.[5] Another, from Cappadocia, is quite similar. It relates that at the building of the bridge of Adana, Yiannaki's wife is buried in the excavation, and laments, with her last breath

> *Three only sisters once were we, we were three sisters only,*
> *The one did build the Danube's bridge, the second the Euphrates',*
> *And I, I too, the murdered one, the bridge build of Adana.[6]*

Or in another nursery rhyme there may be a recollection of sacrificial hunting, as in *The Cutty Wren:*

> *O where are you going, says Milder to Malder,*
> *O, I cannot tell, says Festel to Fose,*
> *We're going to the woods, says John the Red Nose . . .*

In Western Europe among the creatures that were sacrificially hunted were a number of small birds. Many of our nursery rhymes relate to the hunting of the wren. A peculiar importance was attached to this bird from a remote period in antiquity, possibly on account of the golden crest worn by one kind of these birds. In Greek the wren was the *basiliskos,* in Latin he was *regulus* or *rex avium.* In France he is *roitelet;* in Italy, *rea-tino;* in Spain he is *reyezuolo;* in Germany, *zaunkönig.* Possibly his sacrifice was accepted in the place of the periodical sacrifice of the real king, a primitive custom which goes far back in history.[7] Even today in certain parts of Ireland the hunting of the wren is observed annually on St. Stephen's Day, December 26th, the first day of the new year according to the old reckoning. And the Wren Boys, as the hunters are called, chant,

as they march from door to door carrying the body of the dead wren dangling from a pole, "The wren, the wren, the king of all birds!"

MILDER, Malder, Festel, Fose and John the Red Nose are the traditional huntsmen of Wales. In Scotland, their equivalents are Fozie-Mozie, Johnny Rednosie, and Foslin. In England, they are Robbin, Bobbin, Richard and John-all-alone. Of these only Robbin and Bobbin and Richard reappear in other nursery pieces. In the oldest extant collection, *Tom Thumb's Pretty Song Book* of 1744, their heroic capacity for taking advantage of the hunters' first share of the feast is celebrated in the lines,

> *Robbin and Bobbin, two great belly'd men,*
> *They ate more victuals than three-score men.*

Sometimes the names are run together, as

> *Robbin-a-Bobbin bent his bow,*
> *And shot at a woodcock and kill'd a yowe:*
> *The yowe cried ba, and he ran away,*
> *But never came back till midsummer day.*

Other pieces record their monumental sloth in setting forth to the chase,

> *Robbin and Richard were two pretty men,*
> *They lay in bed till the clock struck ten, . . .*

AGAIN these tales and rhymes often embody vestigial survivals of widespread pre-Christian beliefs. The nursery tale of *Little Red Riding Hood,* to which Sir Walter Scott referred, is an instance. It has probably grown out of a myth of sunset and sunrise. The little heroine's red cloak is the first piece of evidence. There are many parallels in the fancies of savage peoples all over the world. The Letts have a story which tells how the daughter of the sun hung her cloak on an oak tree. At the other end of the world, the Australians of Encounter Bay say that the sun is a woman who

has a lover among the dead who has given her a red kangaroo skin in which she appears at her rising. The wolf is a very natural personification of the night. The French phrase for twilight, *entre chien et loup,* is sufficient to explain why. The dog is the domesticated animal that goes about with his master in the light of day, but the wolf is the beast that hides until nightfall and then haunts the darkness. Our English version of *Little Red Riding Hood* obscures the significance of the story because it omits the grotesque climax, probably under the influence of Perrault's sophisticated version, *Le Petit Chaperon Rouge.* But the German version of the story, *Rothkäppchen,* ends with the arrival of the hunter who rips open the sleeping wolf, when the little damsel in her red cap comes out again safe and sound. It is the picturesque story of the adventure of the red sun devoured by the monstrous darkness of sunset, and then disgorged again at sunrise.[8] And we can see the persistent psychological appeal this image of envelopment holds for the child, as for the primitive, from some verses by an American child of eight years who certainly was unapprised of the symbolism of *Rothkäppchen,* if she had ever even heard the tale in translation:

> *The night is wrapped around the day*
> *And when the daytime tears*
> *The night has its time.*
> *When the day is mended*
> *The night is ended.*

AGAIN, "Lady bird, lady bird, fly away home," in the opinion of the German folklorist Mannhardt, originated as a charm intended to speed the sun across the dangers of the sunset, that is, the "house on fire" or welkin of the west which is set aglow at sundown.[9]

JACK AND GILL, Jill in later versions, are probably distortions of Hjuk, or Hjuki, and Bil of the Scandinavian legend first pointed out in this connection by Baring-Gould;[10] and their ascent, fall, disappearance and eventual rehabilitation undoubtedly a myth of the waxing and waning of the moon. It happens that in this case we can trace the literary descent of the myth so that it is scarcely a matter of conjecture at all.

In the Younger Edda, *as Henry Bett explains, we find the story of Hjuki and Bil. Mani is a man who has been placed in the sky to guide the moon in its course and to regulate its waxing and waning aspects. One day Mani carried off from earth children Bil and Hjuki, as they were return-ing from the spring called Byrgir, carrying between them the bucket called Saegr on the pole Simul which they bore on their shoulders. . . . To this day, the Swedish peasantry explain the markings on the moon's surface . . . as a boy and a girl bearing a pail of water between them. The very names show the significance of the legend. Hjuki is derived from a* root meaning *to* increase, Bil *from one meaning to* dissolve. . . . *The water they bear marks the relation of the tides to the moon — a relation that must have been noticed from very early times.*[11]

UNTIL comparatively recent times, little thought was given these "trifles of the nursery." The professional antiquary regarded them as undignified and unworthy of notice. Only with the rise of the new science of folklore in the early nineteenth century did they begin to be taken seriously. It was then realized that they are to be found all over Europe, and that they have analogues among uncivilized peoples all over the world. Many also, it appeared, were of an incredible antiquity. That such trifles should have lasted any great time is surprising. But it is difficult to exaggerate the extreme tenacity of tradition in little things. Nothing is more remarkable than the way that a phrase or a custom will survive ages after its original significance has been forgotten.[12]

Even when we turn to a song so evidently Christian, as the Dorsetshire version of the Creed chant still sung at Eton

> *I'll sing you the twelve O,*
> *Green grow the rushes O,*
> *What are your twelve O.*
> *Twelve for the twelve apostles . . .*

we find that this too has had its vicissitudes. In the Jewish Liturgy used at the Seder Service on Passover Eve there is a very similar number rhyme. It is known as "Ehad Mi Yodea?" ("One: who knows?") from the Ara-maic words with which it begins. After each new line all the preceding

lines are repeated in the familiar fashion of the cumulative chant. It begins

> *One: who knows? One: I know: One is our God in heaven and earth*
> *Two? —These are the tables of the Covenant*
> *Three?— There are three Patriarchs*
> *Four? —There are four mothers in Israel*

and carries down to,

> *Thirteen?— There are thirteen attributes of God.*[18]

This is found in Pessach Haggadahs since the fifteenth century. But it is very possible that it in turn was adapted from a Christian chant of the Creed which goes back still farther.[14] The first printed versions of this chant belong to the second half of the sixteenth century. It was set to music in a motet for thirteen voices by Theodor Clinius, a Venetian by birth who died in 1602.

> *Dic mihi quid sit unus?*
> *Unus est verus Deus, qui regnat in coelis.*
>
> *Dic mihit quid sint duo?*
> *Duo tabulae Moysis . . .*

FROM a folk-lore consideration of these rhymes it is clear that they have their roots deep in those "primitive" strata of Man to which Arthur Waley refers. It is also evident that they partake of the same inspiration and of many of the same qualities as do "the wild fictions" and "the simple music" of the people, which Sir Walter Scott admired. But for the enjoyment of these rhymes the underlying significance is of little importance. There is no need to know the background of Jack and Gill any more than to know a geographical location for the ghost Village of Erith. It is of small importance whether or not Lucy Locket and Kitty Fisher were two famous courtesans of the reign of Charles II, or if Elsie Marley was the merry ale wife who lived near Chester and is celebrated by a song in the *Chester Garland*. Nor need we know that Dr. Fell was the founder of the Clarendon Press at Oxford, that the Duke of Cumberland was one of the great reformers of British Army Training, or the use of the "Buff and

Blue" by the Jacobites. Since the songs are, or at any rate were, passed along orally and since the song, not the fact, is of interest, the historical reference frequently takes the color of its environment. For example, the rhyme,

> *Dr. Faustus was a good man,*
> *He whipped his scholars now and then ...*

seems to carry a distorted memory of the magical powers of that dim figure who was to become the hero of Goethe's poem to transport his scholars from one land to another whether by whip or by wand. But when this rhyme was transplanted to Boston in the early nineteenth century,[15] where the Irish immigrants possibly did not enjoy the highest esteem, we find it still further distorted into:

> *John O'Gudgeon he was a wild man,*
> *He whipt his children now and then ...*

THE important thing, therefore, is not their significance but their literary qualities—their universality and vitality of appeal. As Robert Graves says, *The Piper and the Cow* "appeals to most children as an irresistibly shrewd comment on life, even though they cannot read it as an allegory of the late eighteenth-century farm laborer and landlord class, which is its alleged origin."[16] The faerie charm of "I had a little nut tree" is not enhanced by a knowledge of its probable reference to Joanna of Castile who visited the court of Henry the Seventh in the year 1506. And even the pathetic, late nineteenth century crime of Lizzie Borden has taken an almost legendary quality in the rhyme.

THE anonymous authors of these rhymes have evidently approached the particular incident as raw material. They have stripped it of its local and occasional detail and stressed its fundamental elements of widest suggestion. They have depicted it with the intensity of focus which is the child's gift. They have taken a near-sighted view of detail, both psychological and physical. They have exerted the greatest emphasis where certain aspects of the particular event produced emotional repercussions which they felt more than they understood. They realized the poetic possibilities of incongruity. Nonsense for them was not a mere negation of sense; it

xiv

was the bringing out of a new and deeper harmony of life through its contradictions. They realized that nature in itself is a dull affair, soundless, scentless, colorless, merely the marrying of material endlessly, meaninglessly, and that the magic agency is the human mind. They realized that truth to nature does not constitute reality. Yet their visual images were always sharp, with clear-cut outlines, and drawn with a sure hand. Their expression was kept vital by avoiding formalism and by employing a vernacular informality of phrase and a conversational freedom of cadence.

AND when certain adult poets, writing for adults, produce verses which fit in with traditional nursery literature, it is not necessarily true that they had this approach consciously in mind. It is unlikely, for example, that Pope had in the lines "I am His Highness' dog at Kew." Perhaps even Brown and Porson, were unaware of the road they were so effectively following. Yet in such verses they embody the same clarity of image, the same directness of expression and homely, fundamental humor we find in the finest anonymous nursery songs.

BLAKE on the other hand was extremely conscious of the child's point of view and had much of the child's in his own. And when we come to Keats in a period when the Romantic revival was laying so much stress on the child and on folklore, we can feel sure he was not unaware of his nursery paradigms in writing "There was a naughty Boy" in a letter to his sister Fanny. Here he has certainly rung the changes of appeal to the different bodily senses — taste, touch, smell — with all the intensity and vividness of the finest nursery song. And a few years later, at almost the same time that the *Young Lady's Book* was urging its ideals of Moral Deportment, "piety, integrity, fortitude, charity, obedience, consideration," Edward Lear was singing of "the young person of Smyrna,"

> *Whose Grandmother threatened to burn her,*
> *But she seized on the cat,*
> *And said, 'Granny, burn that!*
> *You incongruous old woman of Smyrna.'*

IN our own century the turn to nursery and folk literature is just as frank among the writers as the interest in children's drawings has been

among the painters. They have realized its qualities and the advantages of taking an analogous approach on their own level of expression. Mr. Walter de la Mare's debt to the nursery rhyme is clear throughout his work. It is the quality that gave him his individuality, carrying him out of the hinterland of Preraphaelitism and of the Celtic Twilight. And we see how charmingly and personally Miss Edith Sitwell has responded to the inspiration of "I had a little nut tree" in

> *The King of China's daughter*
> *So beautiful to see*
> *With her face like yellow water, left*
> *Her nutmeg tree.*
> *Her little rope for skipping*
> *She kissed and gave it me—*
> *Made of painted notes of singing-birds*
> *Among the fields of tea.*
> *I skipped across the nutmeg grove,—*
> *I skipped across the sea;*
> *But neither sun nor moon, my dear,*
> *Has yet caught me.*
>
> *The King of China's daughter,*
> *She never would love me*
> *Though I hung my cap and bells upon*
> *Her nutmeg tree.*
> *For oranges and lemons,*
> *The stars in bright blue air,*
> *(I stole them long ago, my dear)*
> *Were dangling there.*
> *The Moon did give me silver pence,*
> *The Sun did give me gold,*
> *And both together softly blew*
> *And made my porridge cold;*
> *But the King of China's daughter*
> *Pretended not to see*
> *Where I hung my cap and bells upon*
> *The nutmeg tree.*

Mr. W. H. Auden has clearly adapted the pattern and spirit of *The Cutty Wren* in his *Epilogue* to *The Orators*:

> 'O where are you going,' said reader to rider,
> 'That valley is fatal where furnaces burn,
> Yonder's the midden whose odors will madden
> That gap is the grave where the tall return.'
>
> 'O do you imagine,' said fearer to farer,
> 'That dusk will delay on your path to the pass, ...

And we find the actual chant of the Irish Wren Boys — "The wren, the wren, the king of all birds" echoed several places in Joyce's *Finnegans Wake*; notably in one where Joyce refers to the Eve, the All-Mother, and the part she played in the Fall of Man,

> *The rib, the rib, the quean of oldbyrdes, Sinya Sonyavitches!*

And Mr. T. S. Eliot appears, consciously or unconsciously, to have mixed the grim rhythms of the American child's favorite

> You never know as the hearse rolls by
> When it will be your turn to die ...

with W. S. Gilbert's "Nightmare Song" from *Iolanthe*

> When you're lying awake with a dismal headache, ...
> You're a regular wreck with a crick in your neck ...

in the last chorus of *Sweeney Agonistes*:

> When you're alone in the middle of the night and you
> wake up in a sweat and a hell of a fright ...
> And perhaps you're alive
> And perhaps you're dead ...

BUT as children belong to a world completely different from that of adults, none of these poets has been satisfied to imitate the nursery expression strictly. An adult artist can only adapt the virtues of the child's approach to his own ends,—a translation of the child's expression into an adult expression, which in turn will be acceptable to the child; for the child will not abide being talked down to. And this is the quality of Calder's *Three Young Rats* illustrations: his instinct for the child's point of view and the completeness with which he has adapted it.

<div align="right">

JAMES JOHNSON SWEENEY

</div>

FOR the versions of the rhymes illustrated, the editor is indebted to the editors and publishers of the following collections:

> *The Nursery Rhymes of England*
> Edited by James Orchard Halliwell
> London. Frederick Warne & Co. (1842)
>
> *Popular Rhymes and Nursery Tales*
> Edited by James Orchard Halliwell
> London. Frederick Warne & Co. (1849)
>
> *The Only True Mother Goose Melodies*
> Introduction by Edward Everett Hale, D.D.
> Boston. Lee & Shephard (1905)
>
> *The Less Familiar Nursery Rhymes*
> The Augustan Books of English Poetry
> Second Series, Number fourteen,
> Edited by Robert Graves
> London. Ernest Benn, Ltd. n. d.
>
> *London Street Games* by Norman Douglas
> London. Chatto and Windus (1931)
>
> *Oxford Book of Light Verse*
> Edited by W. H. Auden
> Oxford. Clarendon Press (1938)
>
> *The Faber Book of Comic Verse*
> Edited by Michael Roberts
> London. Faber and Faber (1942)

Also to *New Verse*, October-November 1935, edited by Mr. Geoffrey Grigson, for "Where are you going said Milder to Malder" published under the title, "A Folk Poem from Various Sources."

For quotations in the introduction the editor's thanks are due Random House, publishers of *The Orators* by Mr. W. H. Auden; Messrs. Faber and Faber, London, publishers of Mr. T. S. Eliot's *Sweeney Agonistes*; and Messrs. Frederick Warne & Co. Ltd., London, publishers of the poems of Edward Lear. The first half of Miss Edith Sitwell's "The King of China's Daughter" appeared in *Clown's Houses* by Miss Edith Sitwell, B. H. Blackwell, Oxford, 1918, as one of several "Variations on an Old Nursery Rhyme"; and the second half, in Miss Sitwell's *The Wooden Pegasus,* B. H. Blackwell, Oxford, 1920, as one of "Seven Nursery Songs"—VI "The King of China's Daughter."

[1] The Royal Banquet, 1859. *Bon Gaultier's Book of Ballads.*

[2] Karl Pearson: *The Chances of Death,* II, p. 53, 54.

[3] E. B. Tylor: *Primitive Culture,* I, p. 107.

[4] E. B. Tylor: *op. cit.,* I, p. 104.

[5] H. Bett: *Nursery Rhymes and Tales,* pp. 32-37.

[6] A. C. Haddon: *The Study of Man,* p. 352, 353.

[7] Lina Eckenstein: *Comparative Studies in Nursery Rhymes,* p. 172.

[8] H. Bett: *op. cit.,* p. 20, 21, 22.

[9] Lina Eckenstein: *op. cit.,* p. 95.

[10] S. Baring-Gould: *Curious Myths of the Middle Ages,* p. 189.

[11] H. Bett: *op. cit.,* p. 21, 22.

[12] H. Bett: *op. cit.,* p. 1.

[13] Exodus XXXIV.

[14] H. Bett: *op. cit.,* p. 50, 51.

[15] *Mother Goose Melodies.* Boston, Monroe & Francis, 1833.

[16] *The Less Familiar Nursery Rhymes.* Edited by Robert Graves, p. iv.

THREE YOUNG RATS

AND OTHER RHYMES

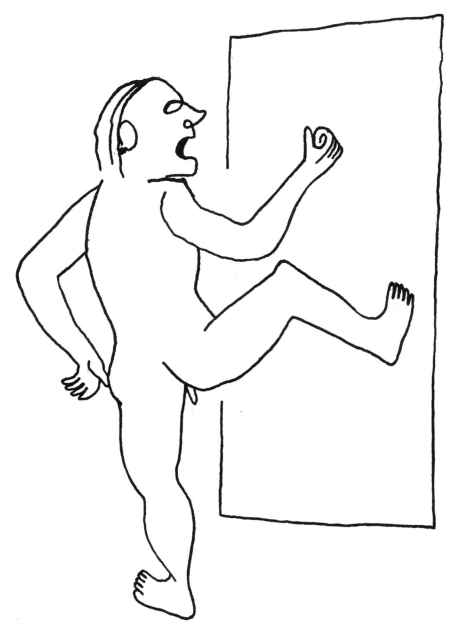

OPEN the door and let me through!
Not without your buff and blue.
Here's my buff and there's my blue.
Open the door and let me through!

THREE young rats with black felt hats,
Three young ducks with white straw flats,
Three young dogs with curling tails,
Three young cats with demi-veils,
Went out to walk with two young pigs
In satin vests and sorrel wigs;
But suddenly it chanced to rain,
And so they all went home again.

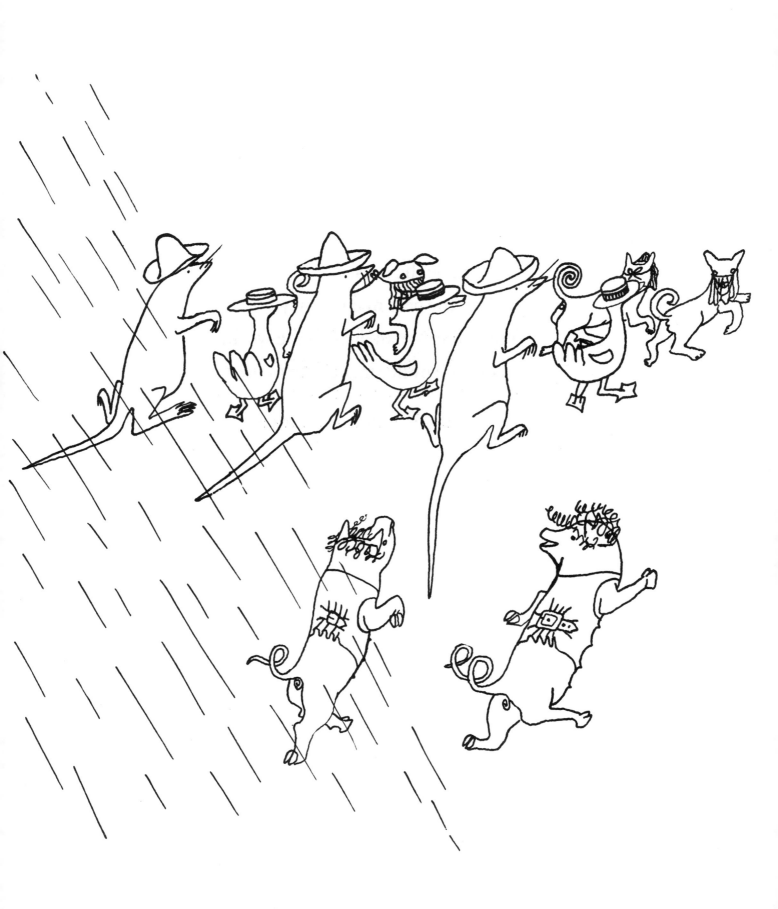

God made the bees,
 And the bees make honey.
The miller's man does all the work,
 But the miller makes the money.

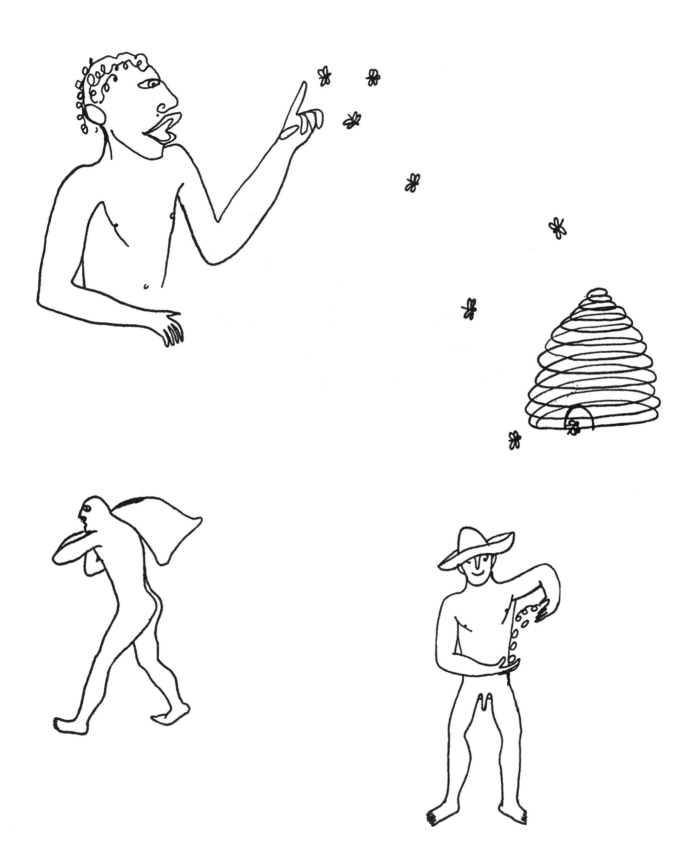

THERE are men in the village of Erith
Whom nobody seeth or heareth,
And there looms, on the marge
Of the river, a barge
That nobody roweth or steereth.

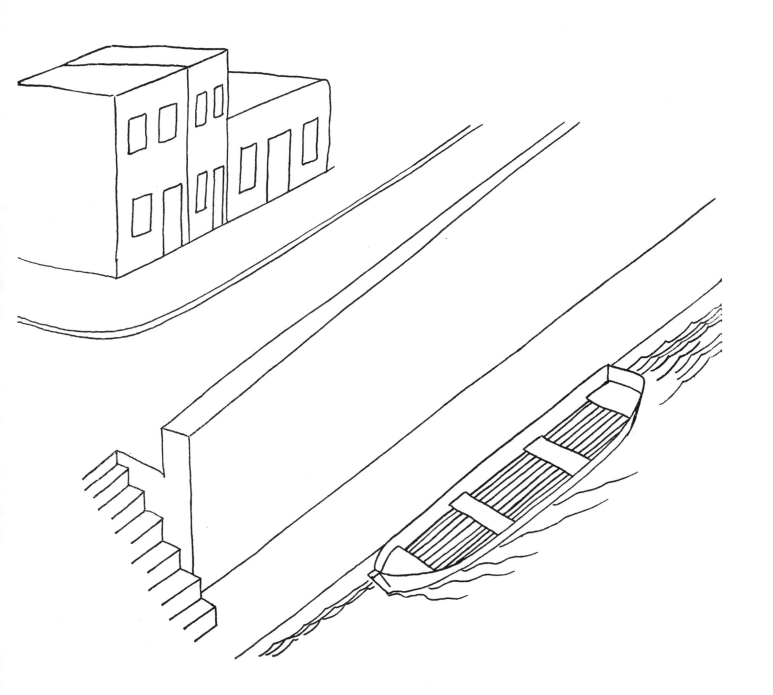

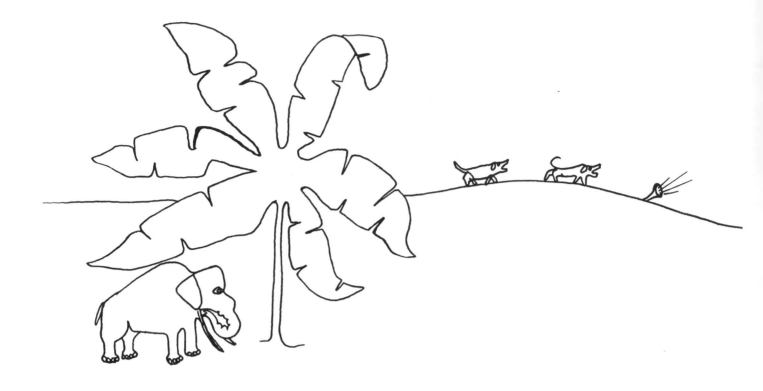

UNDER the umbrageous umbrella trees
Easily the elephant eats at his ease;
The horn of the hunter is heard on the hill
And the hounds are a-barking in harmony shrill.

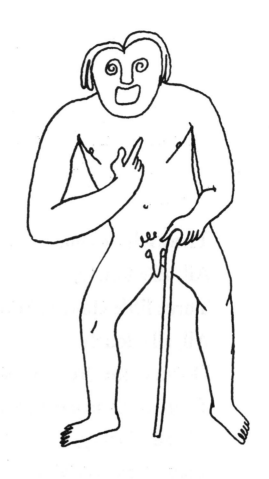

I HAVE a little cough, sir,
In my little chest, sir,
Every time I cough, sir,
It leaves a little pain, sir,
Cough, cough, cough, cough,
There it is again, sir.

THREE little children sitting on the sand,
All, all a-lonely,
Three little children sitting on the sand,
All, all a-lonely,
Down in the green wood shady—
There came an old woman, said Come on with me,
All, all a-lonely,
There came an old woman, said Come on with me,
All, all a-lonely,
Down in the green wood shady—
She stuck her pen-knife through their heart,
All, all a-lonely,
She stuck her pen-knife through their heart,
All, all a-lonely,
Down in the green wood shady.

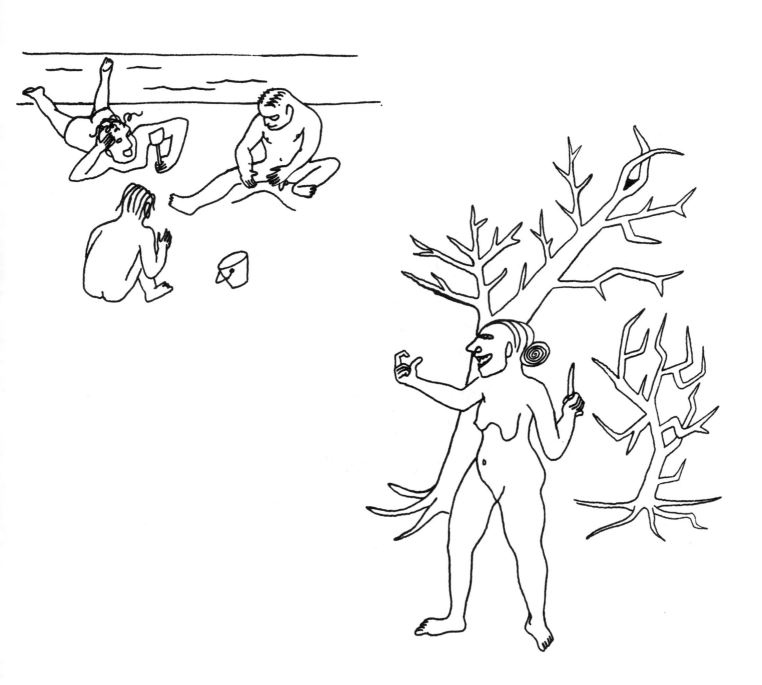

THERE was a piper had a cow
 And had no hay to give her.
He played a tune upon his pipes,
 "Consider, old cow, consider"!

That old cow considered well
 And promised her master money
Only to play that other tune,
 "Corn-rigs are bonny."

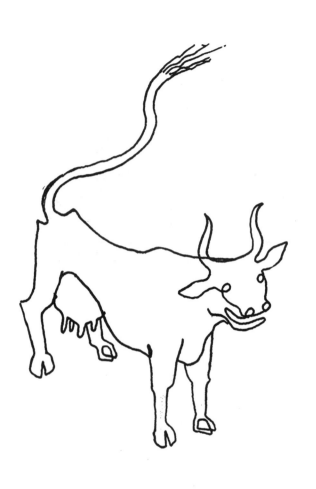
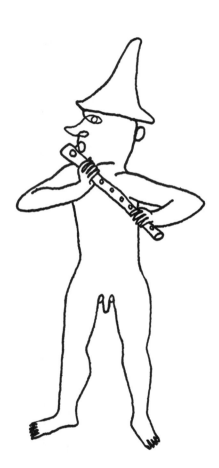

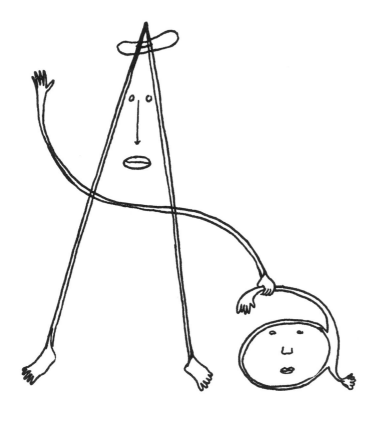

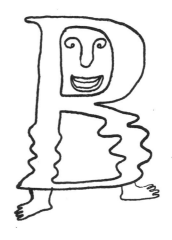

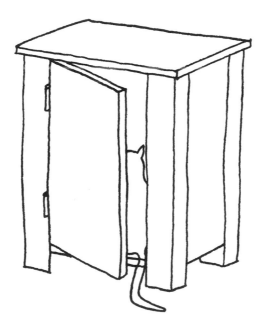

GREAT A, little a,
Bouncing B,
The cat's in the cupboard,
And she can't see me.

14

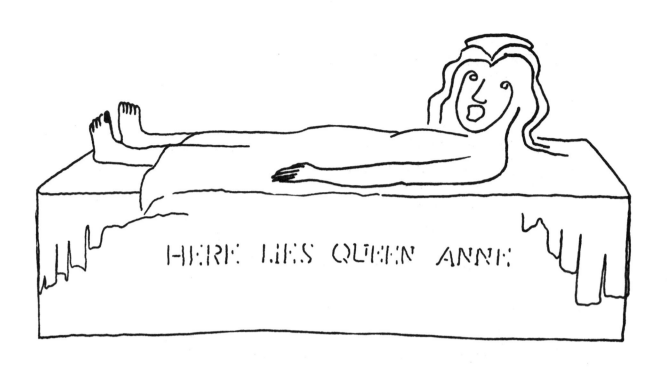

I AM Queen Anne, of whom 'tis said,

I'm chiefly famed for being dead.

Queen Anne, Queen Anne, she sits in the sun,

As fair as a lily, as brown as a bun.

15

On Paul's Cathedral grows a tree
As full of apples as can be.
The little boys of London Town
They come with hooks to pull them down.
Then they run from hedge to hedge,
Until they come to London Bridge.

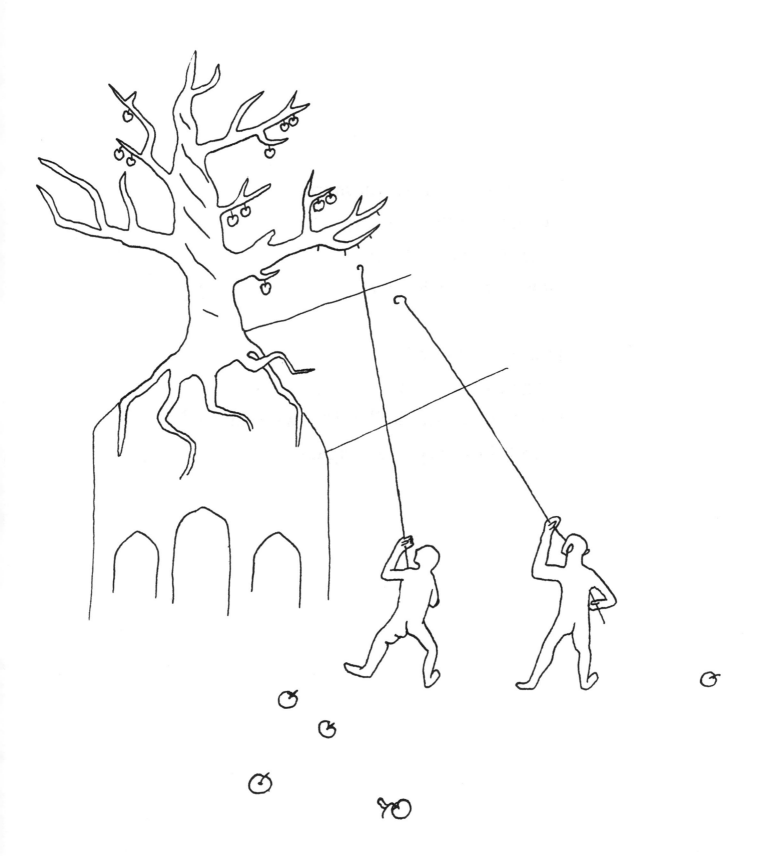

MISTY-MOISTY was the morn,
 Chilly was the weather;
There I met an old man
 Dressed all in leather,

Dressed all in leather
 Against the wind and rain,
With "how do you do?" and "how do you do?"
 And "how do you do?" again.

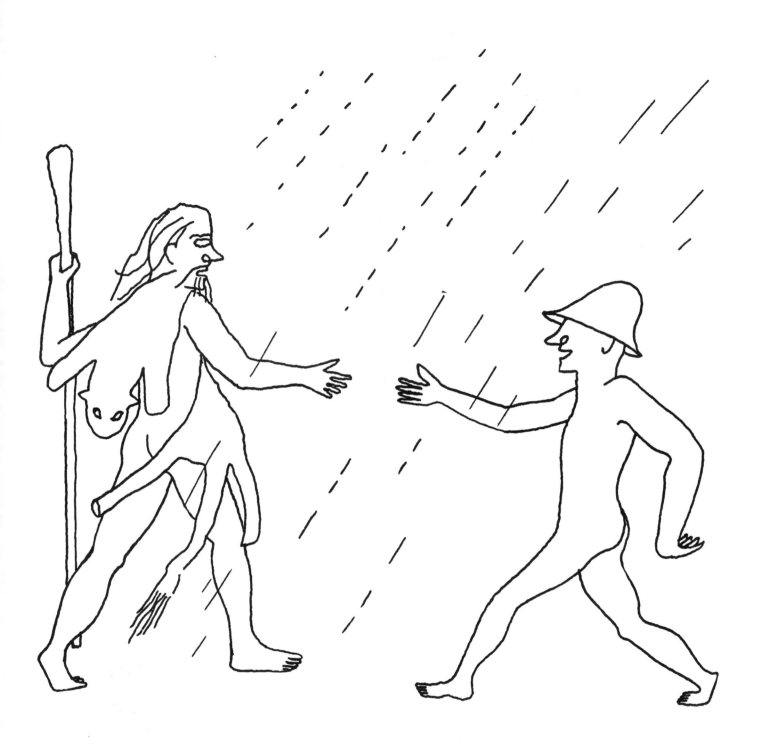

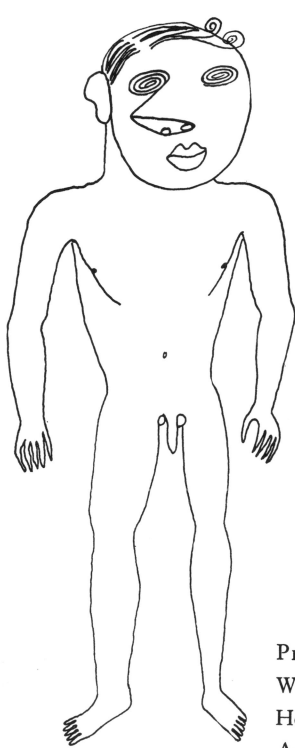

Peter White will ne'er go right,
Would you know the reason why?
He follows his nose where'er he goes,
And that stands all awry.

LUCY LOCKET lost her pocket,
Kitty Fisher found it:
There was not a penny in it,
But a ribbon round it.

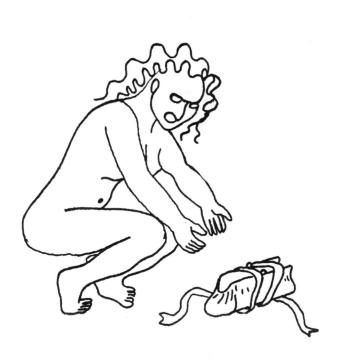

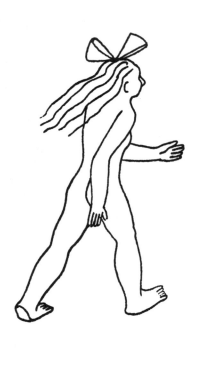

THERE was a mad man
And he had a mad wife
And they all lived in a mad lane!
They had three children all at a birth,
And they too were mad every one.
The father was mad
The mother was mad
The children all mad beside.
And upon a mad horse they all of them got,
And madly away did ride.

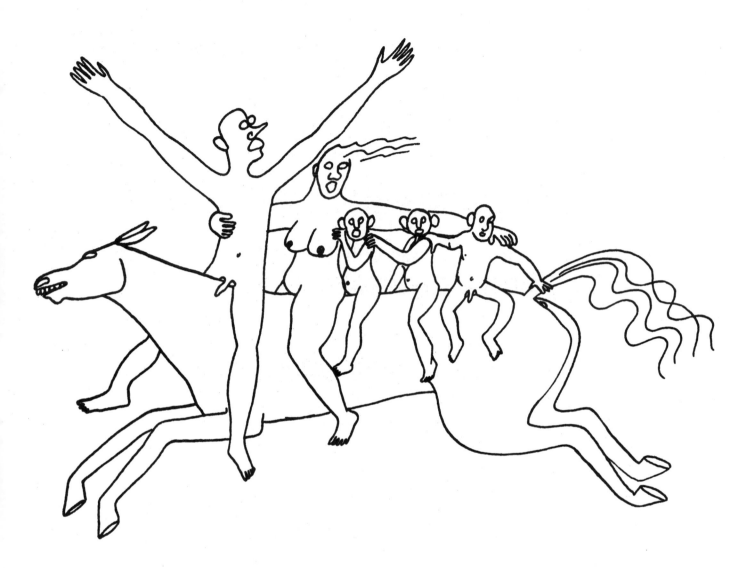

ONE-ERY, Two-ery, Diggory Davey,
Allabone, Crackabone, Hennery Knavey.
Pin, Pan, Muskedan,
Twiddledy, Twaddledy Twenty-one.
O U T spells *out,* and out goes he!

1, 2,

21

OUT

WE'RE all jolly boys,
And we're coming with a noise.
Our coats shall be made
With fine lace brocade,
Our stockings shall be silk
As white as the milk,
And our tails shall touch the ground.

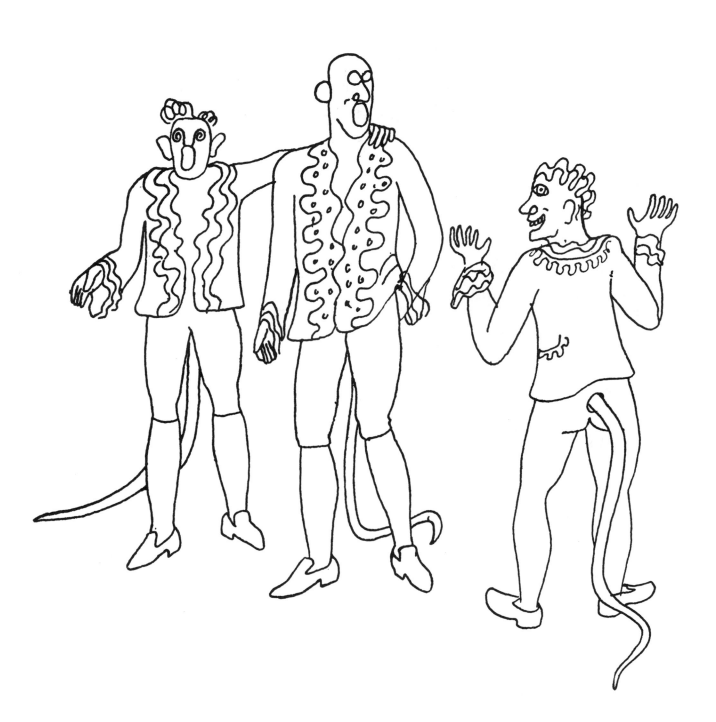

WHAT are little boys made of?
And what are little boys made of?
Slugs and snails and puppy-dogs' tails,
And *that* are little boys made of.

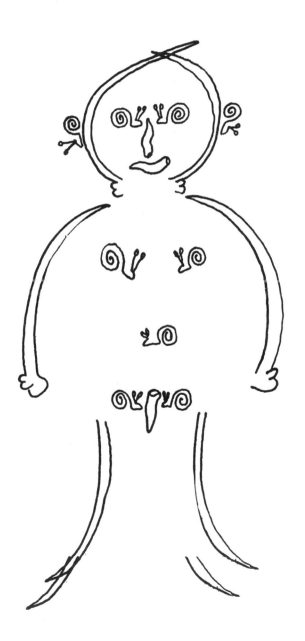

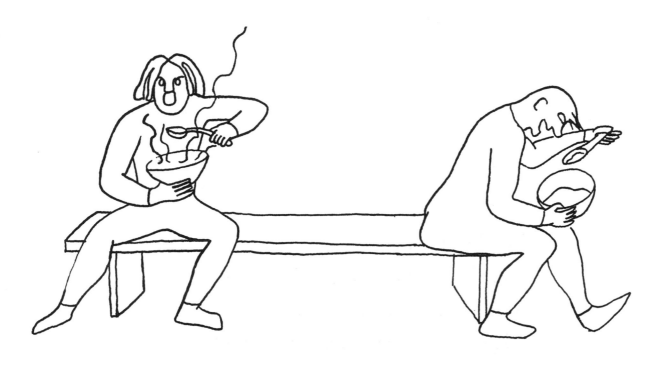

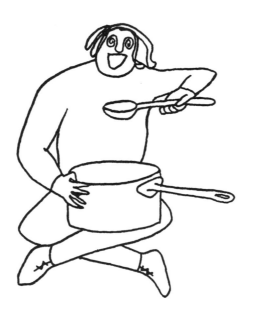

PEASE-PUDDING hot,
Pease-pudding cold,
Pease-pudding in the pot
Nine days old.

Some like it hot,
Some like it cold,
Some like it in the pot
Nine days old.

FEE, Fie, Fo, Fum!
I smell the blood of an English man.
Be he alive, or be he dead,
I'll grind his bones to make my bread.

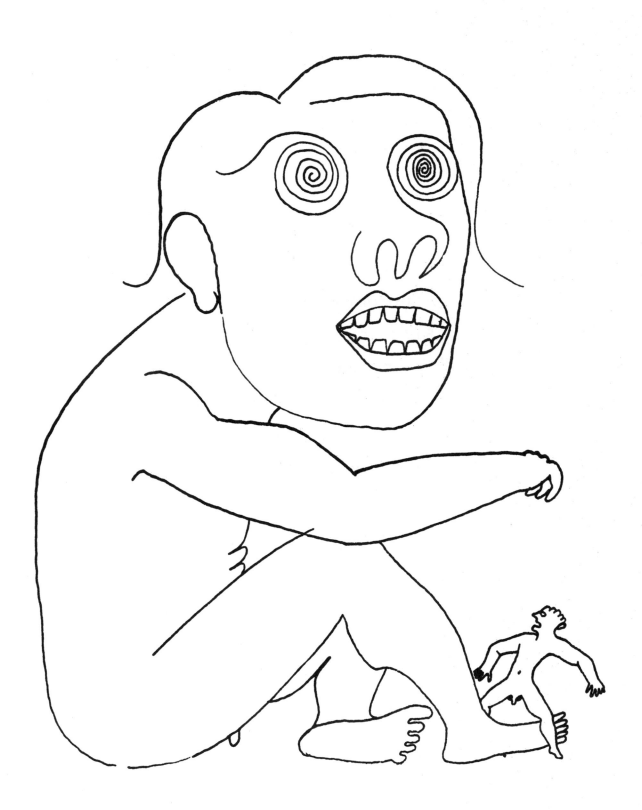

Goosey, goosey, gander,
Where shall I wander?
Up stairs, down stairs,
And in my lady's chamber;
There I met an old man,
That would not say his prayers;
I took him by the left leg,
And threw him down stairs.

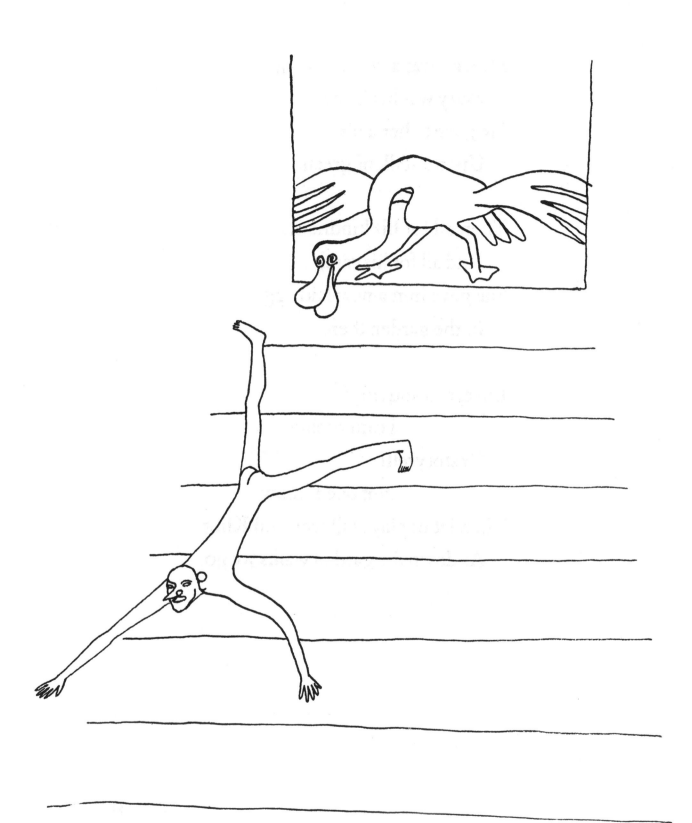

HENRY was a worthy King,
 Mary was his Queen,
He gave to her a lily
 Upon a stalk of green.

Then all for his kindness,
 And all for his care,
She gave him a new-laid egg
 In the garden there.

Love, can you sing?
 I cannot sing.
Or story tell?
 Not one I know.
Then let us play at Queen and King
 As down the garden walks we go.

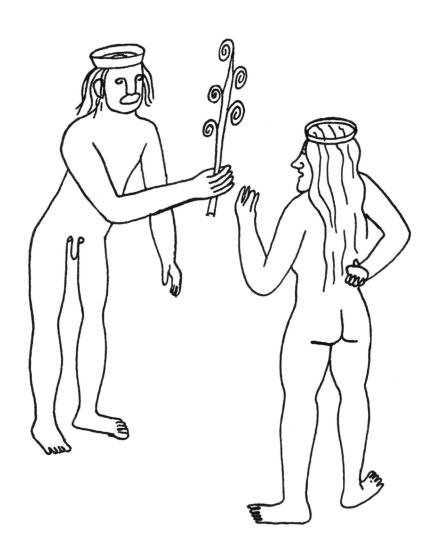

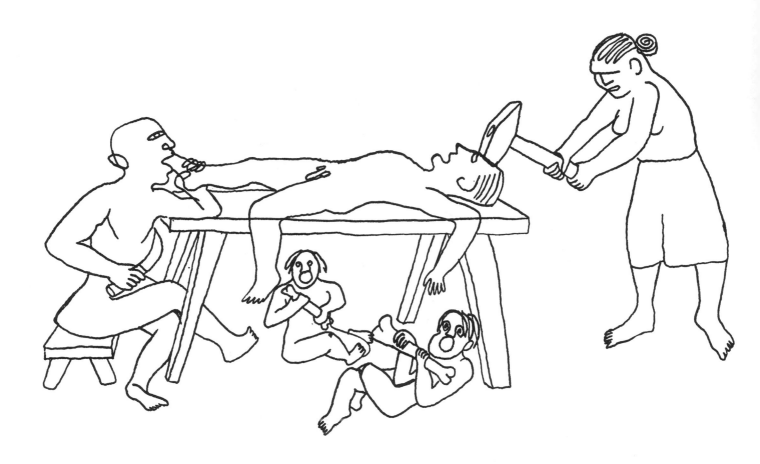

My mother has killed me,
My father is eating me,
My brothers and sisters sit under the table
Picking up my bones,
And they bury them under the cold marble stones.

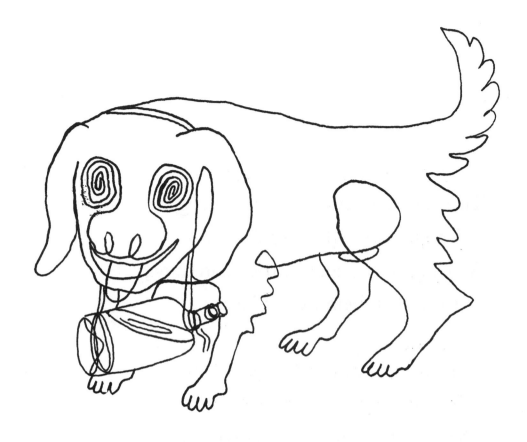

THE dogs of the monks
 Of St. Bernard go,
To help little children
 Out of the snow.

Each has a rum-bottle
 Under his chin,
Tied with a little bit
 Of bobbin.

37

To ARTHUR's court, when men began
 To wear long flowing sleeves,
A Scot, a Welsh and an Irishman came,
 And all of them were thieves.

The Irishman he loved Usquebaugh,
 The Scot loved ale called Blue Cap,
The Welshman he loved toasted cheese
 And made of his mouth a mouse-trap.

Usquebaugh burned the Irishman,
 The Scot was drowned in ale,
And the Welshman was like to be choked by a mouse,
 But he pulled it out by the tail.

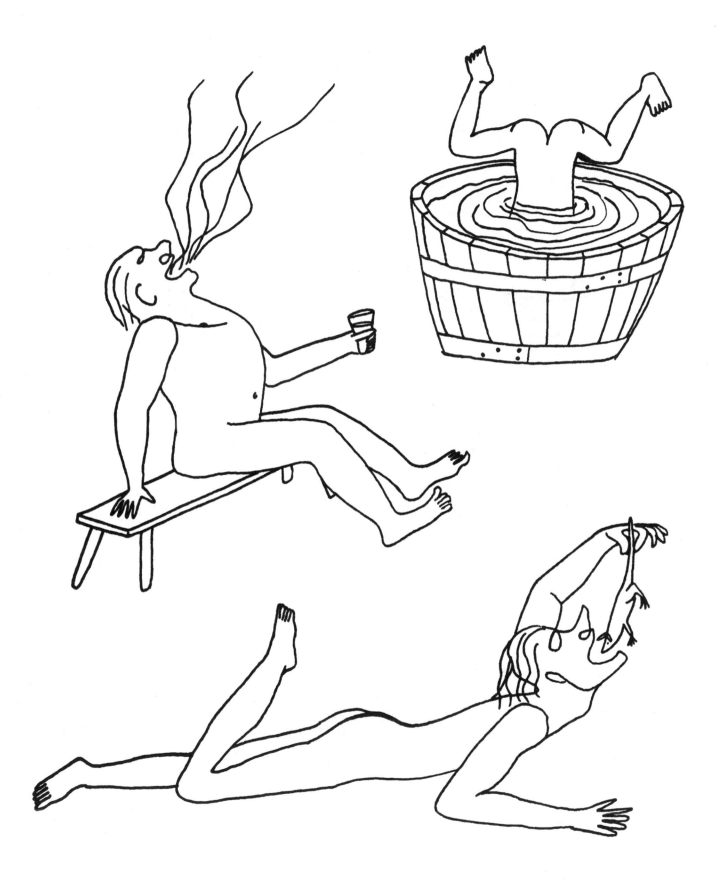

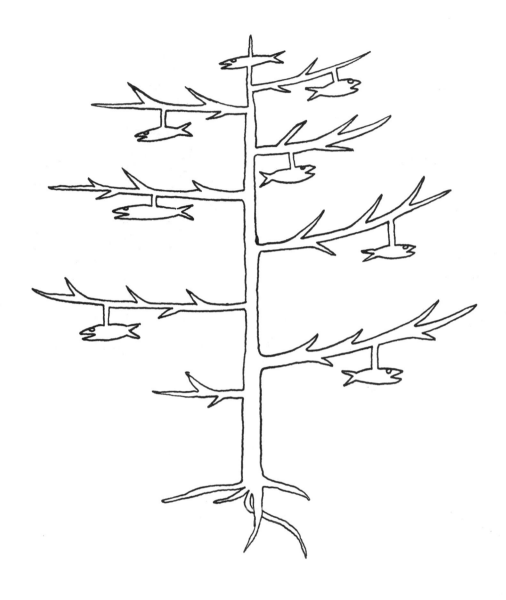

THE man in the wilderness asked of me
 "How many strawberries grow in the sea?"
I answered him as I thought good,
 "As many red herrings as grow in the wood."

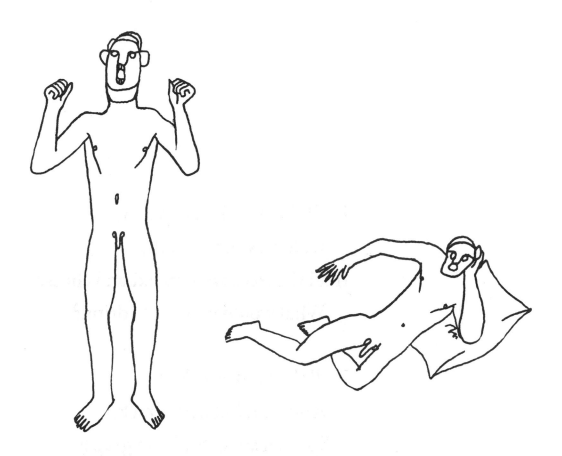

"To BED, to bed," cried Sleepy-head.
"Tarry awhile," said Slow.
 Said Greedy Nan, "Put on the pan,
 Let's dine before we go."

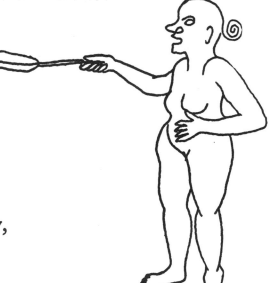

"To bed, to bed," cried Sleepy-head.
 But all the rest said, "No!
 It is morning now; you must milk the cow,
 And tomorrow to bed we go."

41

If all the world were paper,
 If all the seas were ink,
If all the trees were bread and cheese,
 What would we have to drink?

If all the bottles leaked
 And none but had a crack,
If Spanish apes ate all the grapes,
 What would we do for sack?

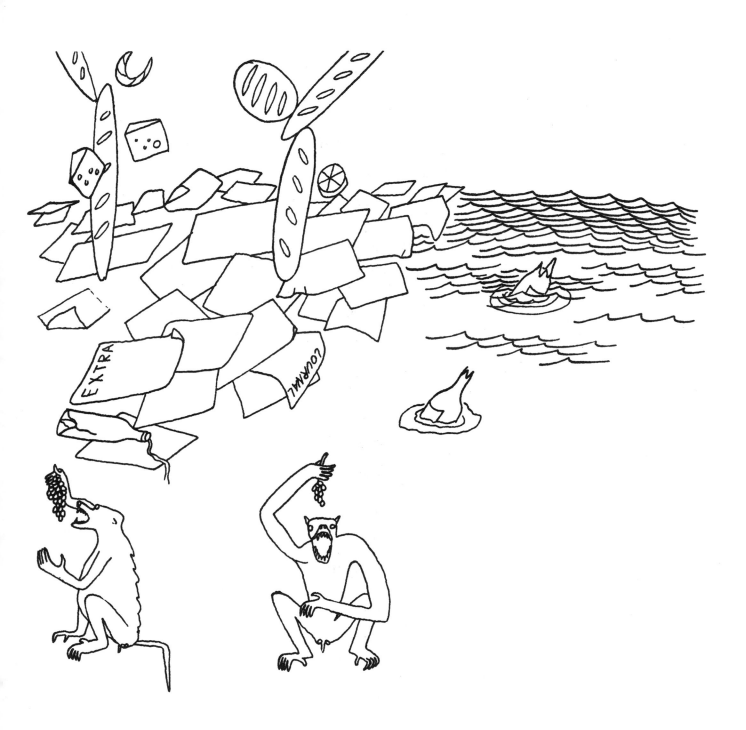

THERE was a naughty Boy,
 And a naughty Boy was he,
He ran away to Scotland
 The people for to see—
 Then he found
 That the ground
 Was as hard,
 That a yard
 Was as long,
 That a song
 Was as merry,
 That a cherry
 Was as red—
 That lead
 Was as weighty,
 That fourscore
 Was as eighty,
 That a door
 Was as wooden
 As in England—
So he stood in his shoes
 And he wonder'd,
 He wonder'd,
He stood in his shoes
 And he wonder'd.

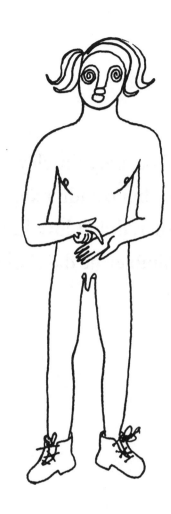

EAPER WEAPER, chimbley sweeper
Had a wife but couldn't keep her,
Had another, didn't love her
Up the chimbley he did shove her.

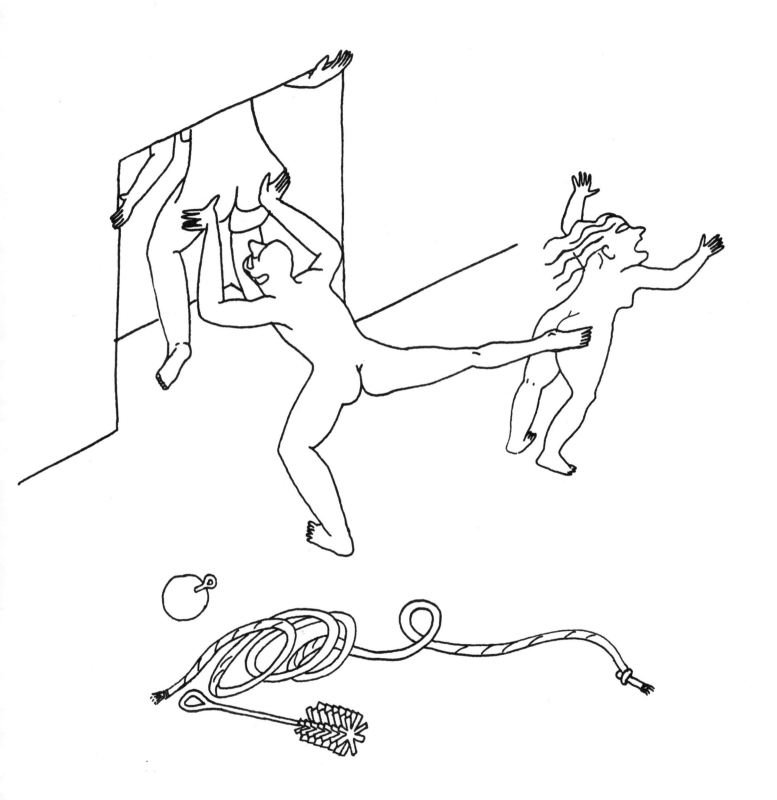

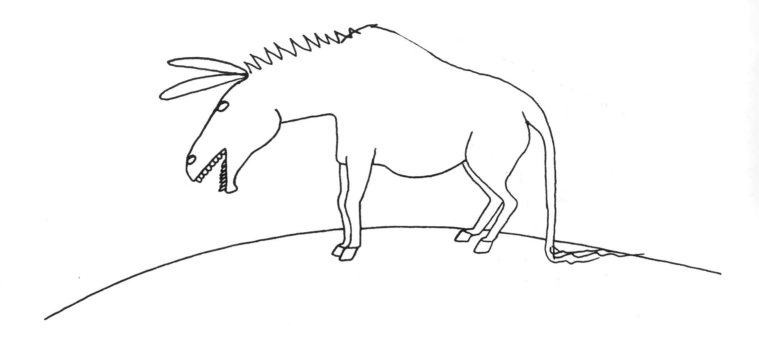

Up in the North, a long way off,
The donkey's got the whooping cough.

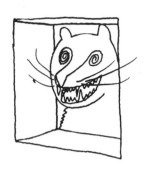

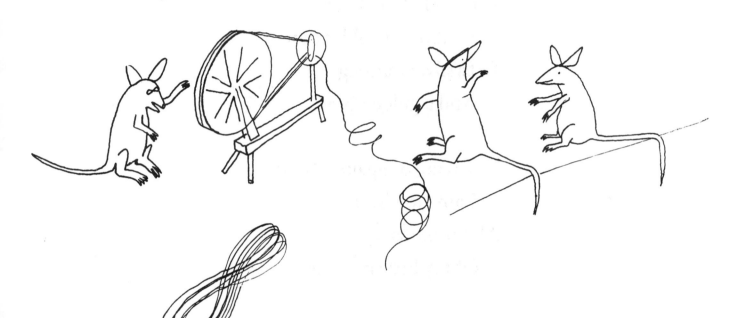

THREE little mice sat down to spin.

Pussy passed by and she peeped in.

"What are you at, my fine little men?"

"Making coats for gentlemen."

"Shall I come in and cut off your threads?"

"Oh no, Mistress Pussy, you'd bite off our heads!"

I HAD a little nut-tree,
 Nothing would it bear
But a silver nutmeg
 And a golden pear.

The King of Spain's daughter
 Came to visit me,
All for the sake
 Of my little nut-tree.

I skipped over ocean,
 I danced over sea,
And all the birds in the air
 Couldn't catch me.

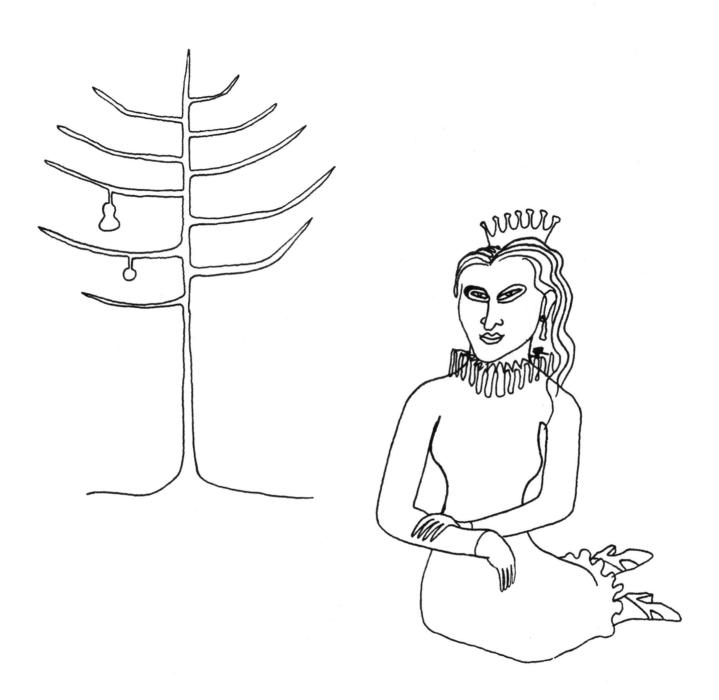

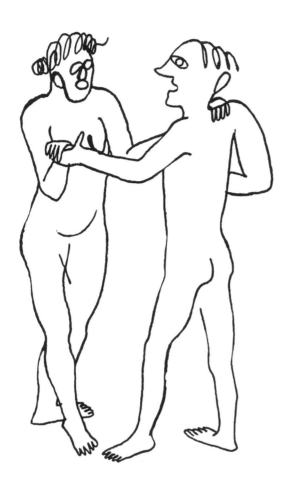

HERE we dance looby-looby,
 Here we dance left and right.
Here we dance looby-looby,
 All on a Saturday night.

Put your left leg in,
 Pull your left leg out;
Give it a bit of a shake
 And turn yourself about.

Put your right leg in,
 Pull your right leg out,
Give it a bit of a twist
 And turn yourself about.

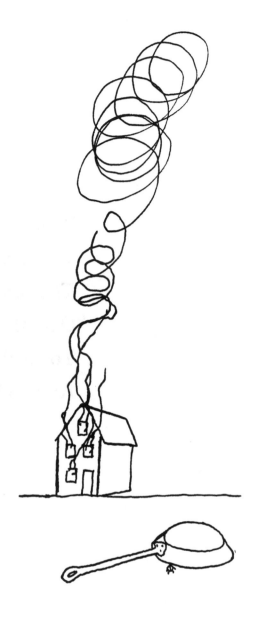

LADYBIRD, ladybird, fly away home!
Your house is on fire, your children are gone.
All except one and her name is Anne;
She crept under the frying-pan.

ROBIN and Richard were two pretty men,
They lay in bed till the clock struck ten;
Then up jumps Robin and looks at the sky,
"O brother Richard, the Sun's very high;
You go before with bottle and bag,
And I'll follow after on little Jack Nag."

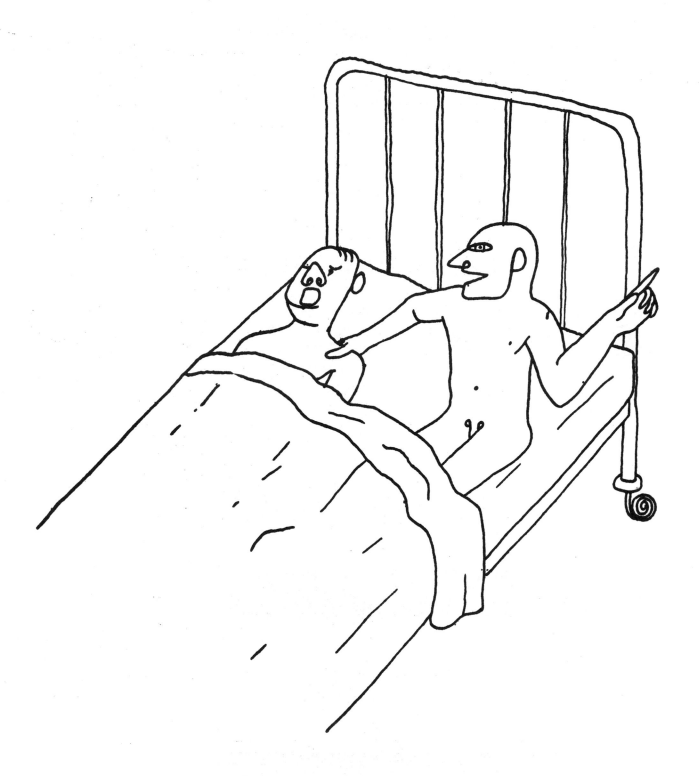

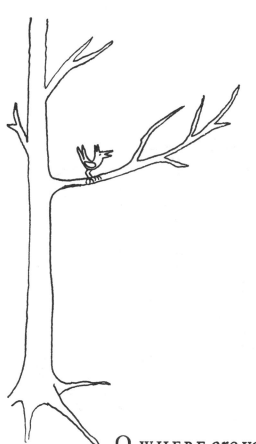
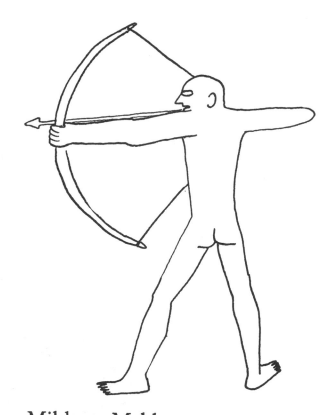

O, WHERE are you going, says Milder to Malder,
O, I cannot tell, says Festel to Fose,
We're going to the woods, says John the Red Nose,
We're going to the woods, says John the Red Nose.

O, what will you do there, says Milder to Malder,
O, I cannot tell, says Festel to Fose,
We'll shoot the Cutty Wren, says John the Red Nose,
We'll shoot the Cutty Wren, says John the Red Nose.

O, how will you shoot her, says Milder to Malder,
O, I cannot tell, says Festel to Fose,
With arrows and bows, says John the Red Nose,
With arrows and bows, says John the Red Nose.

56

O, that will not do, says Milder to Malder,

O, what will do then, says Festel to Fose,

Big guns and cannons, says John the Red Nose,

Big guns and cannons, says John the Red Nose.

O, how will you bring her home, says Milder to Malder,

O, I cannot tell, says Festel to Fose,

On four strong men's shoulders, says John the Red Nose,

On four strong men's shoulders, says John the Red Nose.

O, that will not do, says Milder to Malder,

O, what will do then, says Festel to Fose,

Big carts and waggons, says John the Red Nose,

Big carts and waggons, says John the Red Nose.

O, what will you cut her up with, says Milder to Malder,

O, I cannot tell, says Festel to Fose,

With knives and with forks, says John the Red Nose,

With knives and with forks, says John the Red Nose.

O, that will not do, says Milder to Malder,

O, what will do then, says Festel to Fose,

Hatchets and cleavers, says John the Red Nose,

Hatchets and cleavers, says John the Red Nose.

O, how will you boil her, says Milder to Malder,

O, I cannot tell, says Festel to Fose,

In pots and in kettles, says John the Red Nose,

In pots and in kettles, says John the Red Nose.

O, that will not do, says Milder to Malder,

O, what will do then, says Festel to Fose,

Brass pans and cauldrons, says John the Red Nose,

Brass pans and cauldrons, says John the Red Nose.

O, who'll have the spare ribs, says Milder to Malder,

O, I cannot tell, says Festel to Fose,

We'll give them to the poor, says John the Red Nose,

We'll give them to the poor, says John the Red Nose.

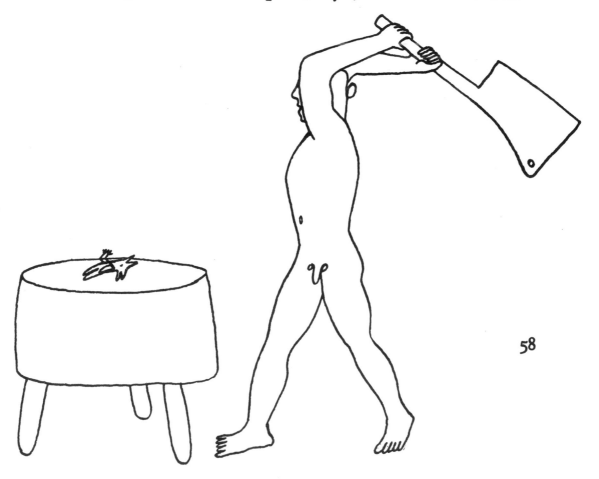

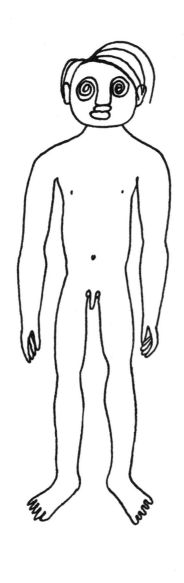
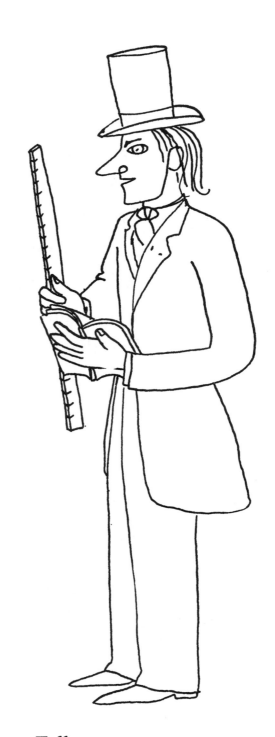

I DO not love thee, Doctor Fell:
The reason why I cannot tell,
But this I know, I know full well,
I do not love thee, Doctor Fell.

Won't, won't, won't, won't,
I won't be my father's Jack,
I won't be my mother's Jill,
I will be the fiddler's wife
And have music when I will;
Will, will, will, will.
T'other little tune, t'other little tune,
Pray thee, love, play me t'other little tune.

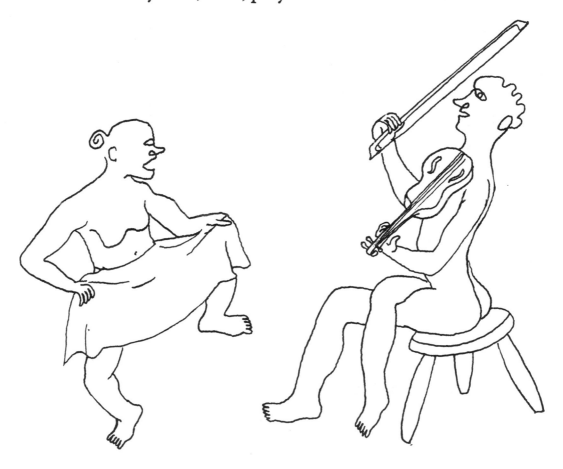

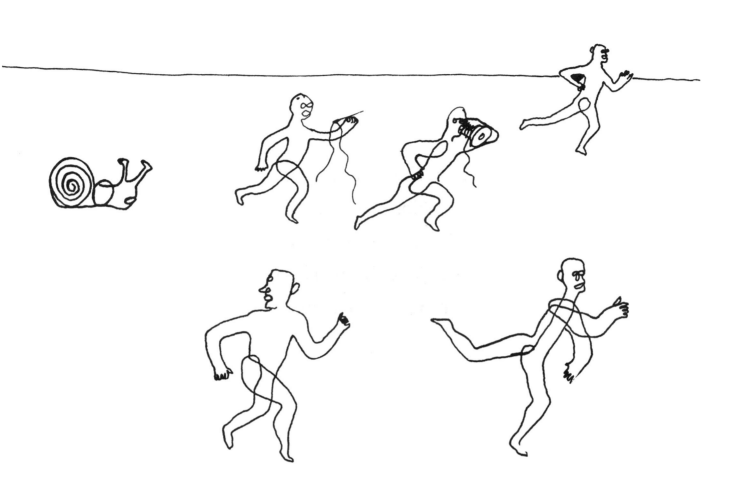

FOUR-AND-TWENTY tailors
 Went to catch a snail.
Even the bravest of them
 Dared not touch her tail.
She stuck out her horns
 Like a little Kyloe cow.
Run, tailors, run,
 Or she'll have you all now!

61

Mr. East gave a feast,
Mr. North laid the cloth,
Mr. West took the best,
Mr. South burned his mouth
Eating hot potatoes.

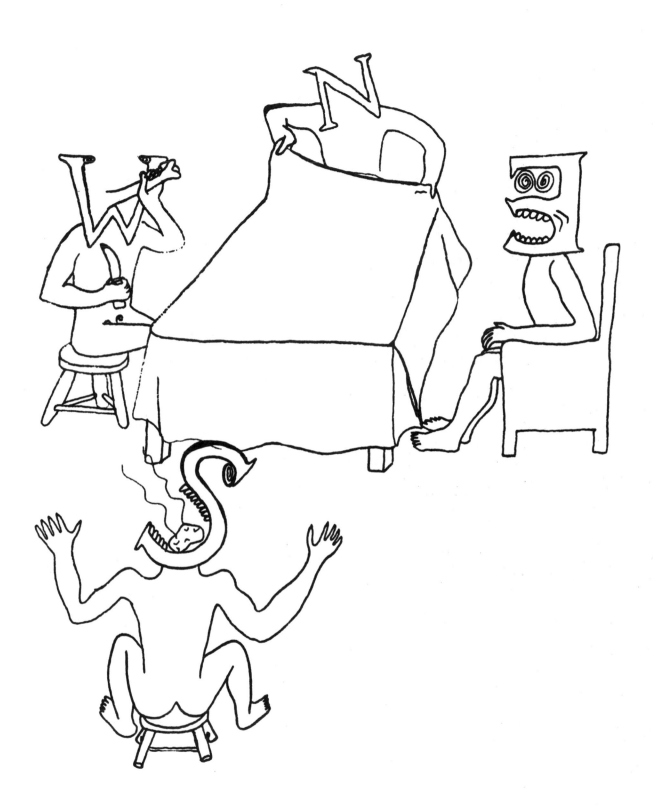

My Mother said, I never should
Play with the gipsies in the wood.

If I did, she would say,
"You naughty girl to disobey.

"Your hair shan't curl and your shoes shan't shine.
You gipsy girl, you shan't be mine."

And my father said that if I did
He'd rap my head with the teapot-lid.

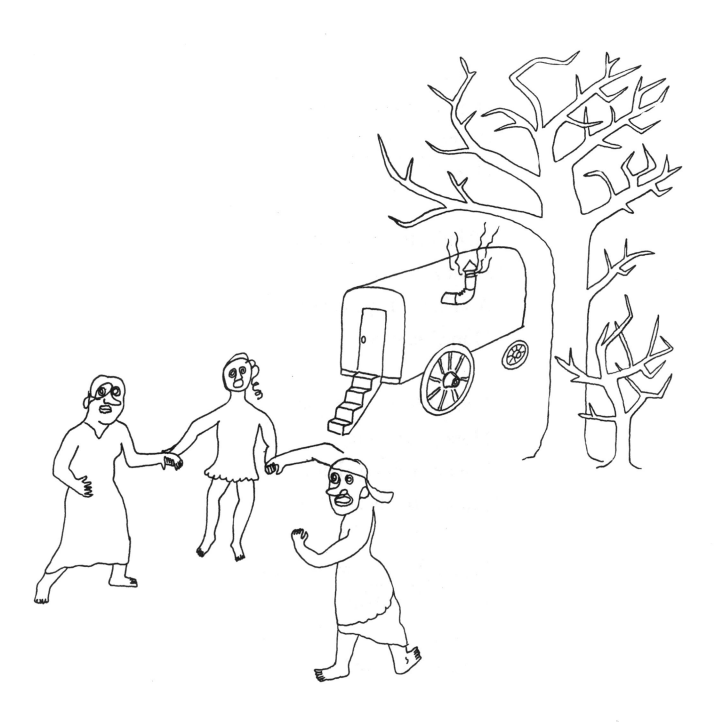

THERE was a lady loved a swine.
"Honey," said she,
"Pig-hog, wilt thou be mine?"
"Hunc," said he.

"I'll build for thee a silver sty,
"Honey," said she,
"And in it softly thou shalt lie."
"Hunc," said he.

"Pinned with a silver pin,
"Honey," said she,
"That you may go both out and in."
"Hunc," said he.

"When shall we two be wed,
 Honey?" said she.
"Hunc, hunc, hunc," he said,
 And away went he.

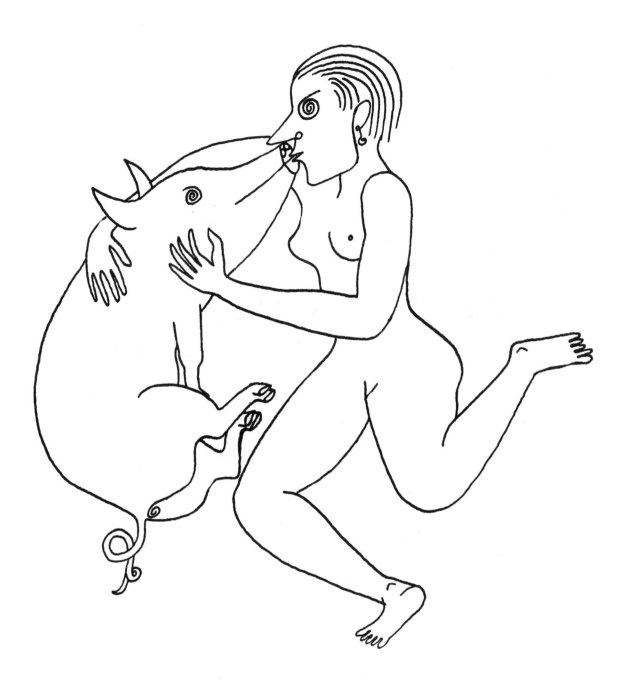

OLIVER CROMWELL is buried and dead.
There grew an old apple tree over his head.

The apples were ripe and ready to fall.
There came an old woman and gathered them all.

Oliver rose and gave her a clop
Which made that old woman go hippity-hop.

Saddle and bridle they hang on a shelf,
If you want any more you must make it yourself.

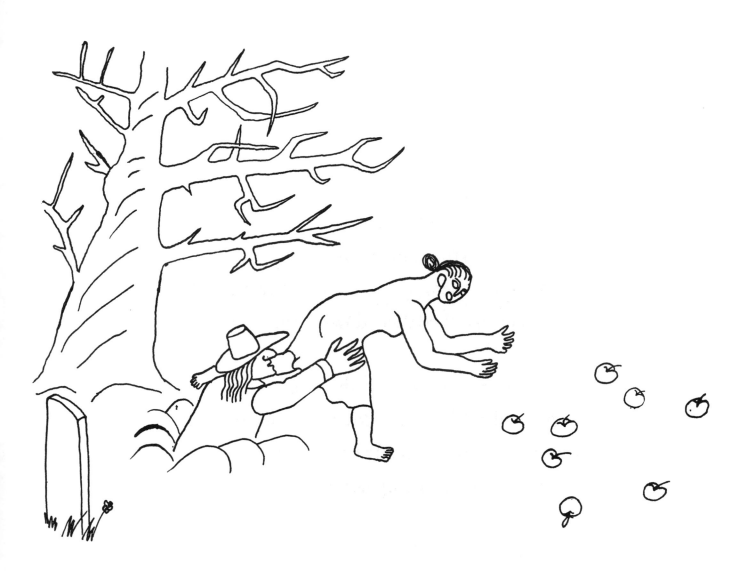

THE Duke of Cumberland
 He had ten thousand men;
He marched them up to the top of the hill
 And he marched them down again.

Then when they were up, they were up,
 And when they were down, they were down,
But when they were only half-way up
 They were neither up nor down.

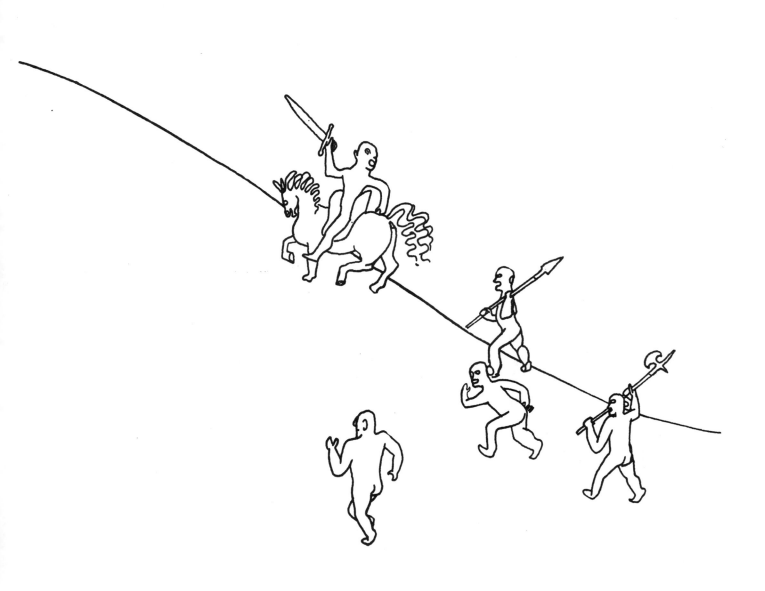

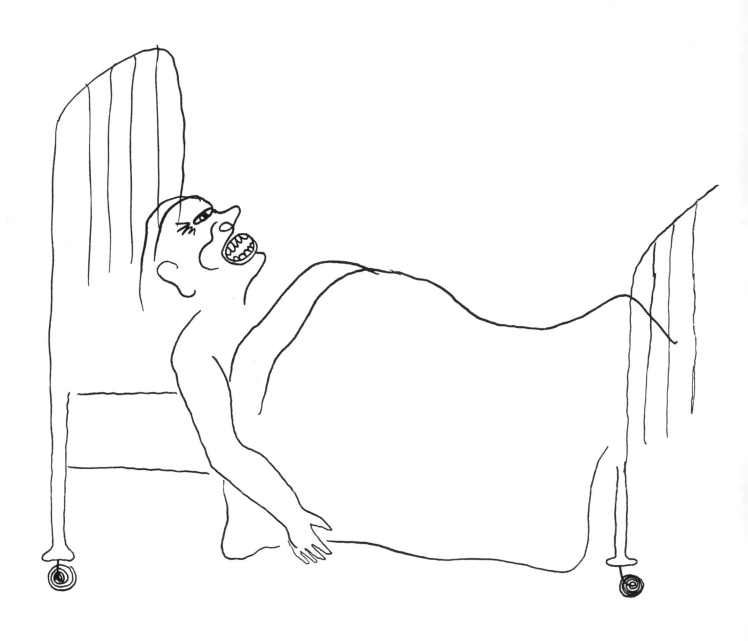

WHAT did I dream? I do not know:
 The fragments fly like chaff.
Yet, strange, my mind was tickled so
 I cannot help but laugh.

MIRROR, Mirror, tell me,
 Am I pretty or plain?
Or am I downright ugly
 And ugly to remain?

Shall I marry a gentleman?
 Shall I marry a clown?
Or shall I marry old Knives-and-Scissors
 Shouting through the town?

73

Nose, nose, jolly red nose,
And what gave thee that jolly red nose?
Nutmeg, cinnamon, spices and cloves,
And they gave me that jolly red nose.

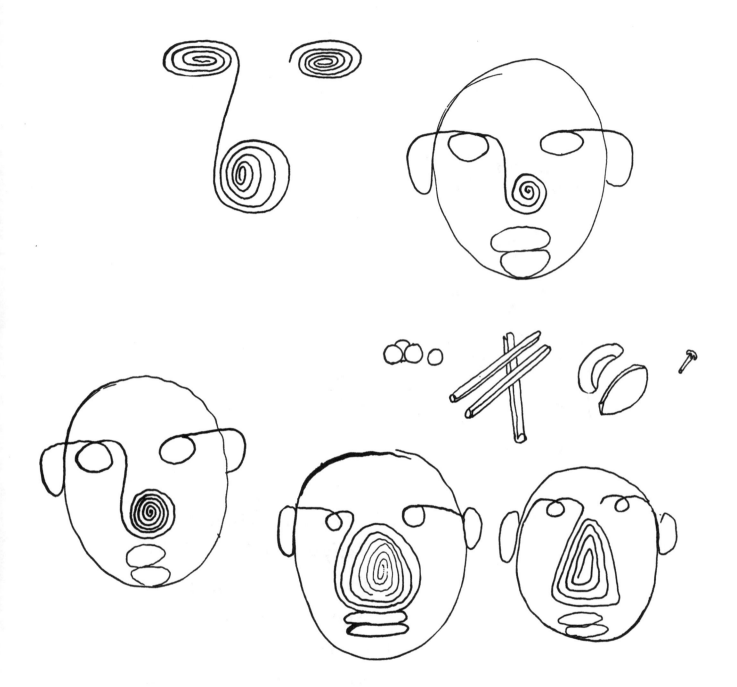

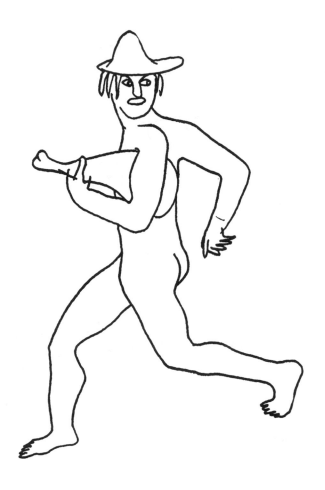

TAFFY was a Welshman,
 Taffy was a thief.
Taffy came to my house
 And stole a leg of beef.
I went to Taffy's house
 And found him not at home,
For Taffy was at my house
 And stole a marrow bone.

A FAMOUS old lady had three sticks,
 Ivory, ebon and gold;
The ivory split, the gold took a crack,
And the ebon she broke about the maid's back.
So this was the end of the three sticks,
 Ivory, ebon and gold.

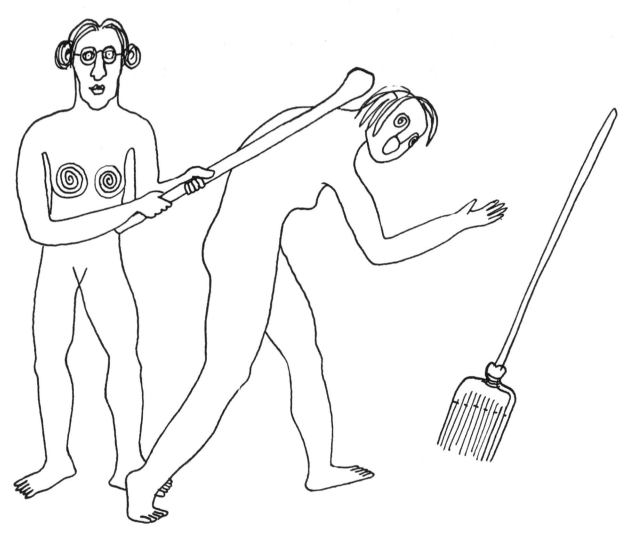

FLOUR of England, fruit of Spain,
Met together in a shower of rain,
Put in a bag tied round with a string,
If you tell me this riddle, I'll give you a ring.

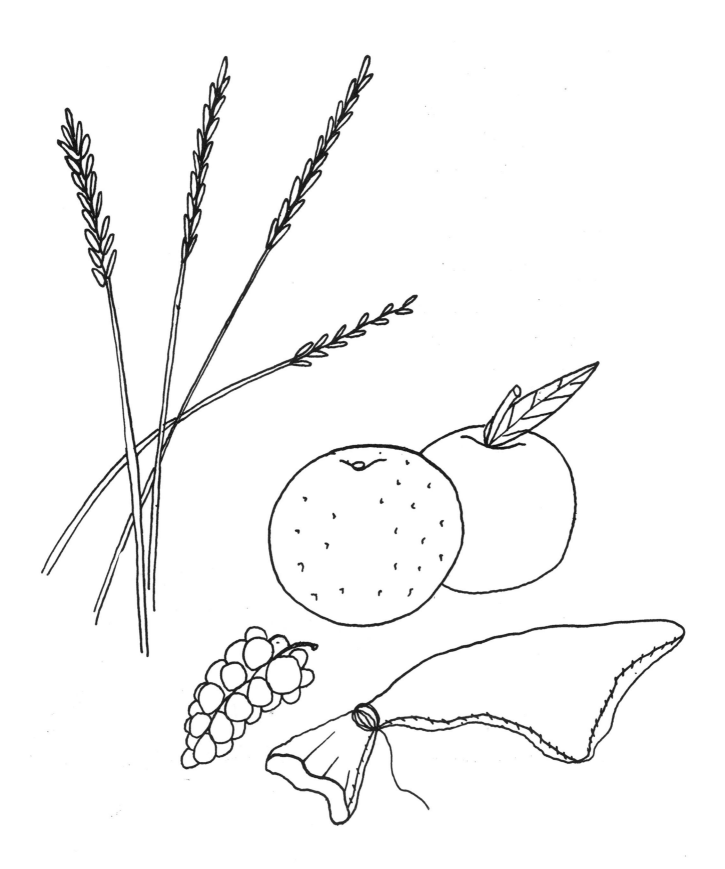

HERE lies old Fred.
It's a pity he's dead.
We would have rather
It had been his father;
Had it been his sister,
We would not have missed her;
If the whole generation,
So much the better for the nation,
But since it's only Fred
Who was alive, and is dead,
There's no more to be said.

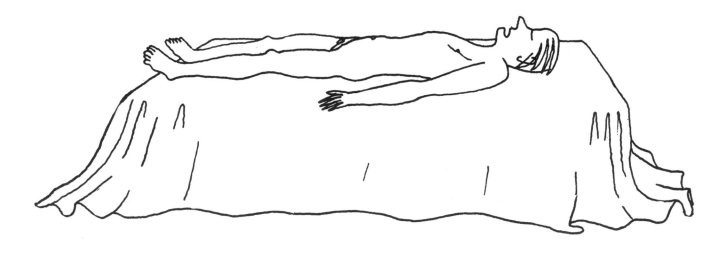

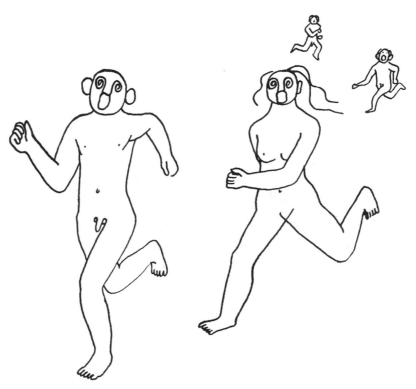

GIRLS and boys, come out to play!
The moon doth shine as bright as day.
Leave your supper and leave your sleep
And join your play-fellows down the street.
Come with a whoop and come with a call,
Come with a good will or come not at all;
Up the ladder and down the wall,
A halfpenny loaf shall cover us all.

81

WHEN a man has married a wife, he finds out whether
Her knees and elbows are only glued together.

83

Calico Pie,
The little birds fly
Down to the Calico tree.
Their wings were blue
And they sang "Tilly-loo"
Till away they all flew,
 And they never came back to me,
 They never came back,
 They never came back,
 They never came back to me.

I WENT to Noke,
But nobody spoke;
I went to Thame,
It was just the same;
Burford and Brill
Were silent and still;
But I went to Beckley
And they spoke directly.

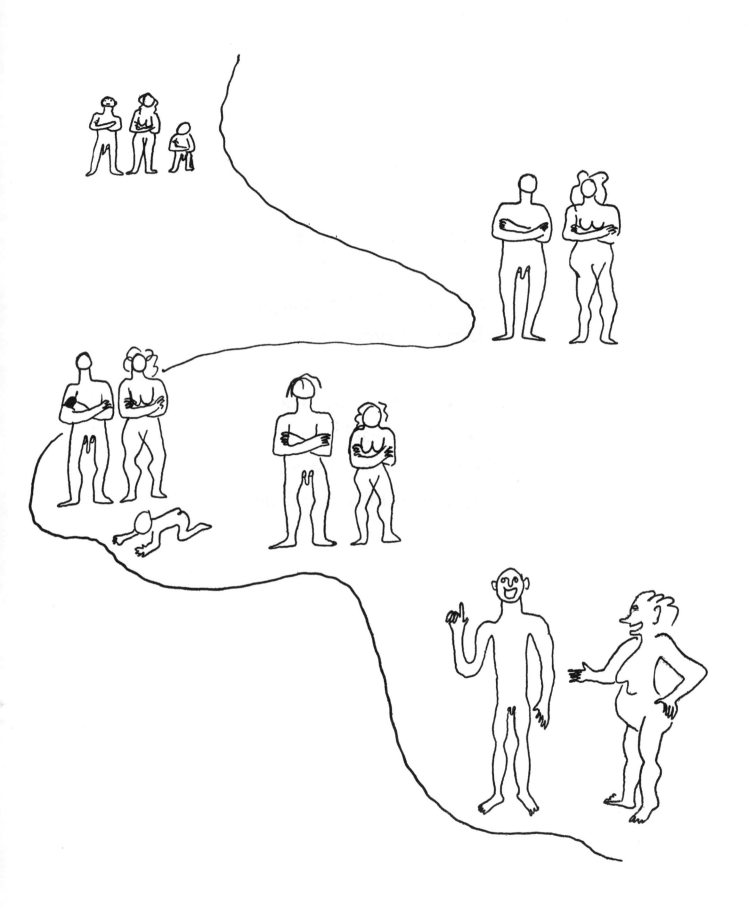

DON'T CARE didn't care,
 Don't Care was wild:
Don't Care stole plum and pear
 Like any beggar's child.

Don't Care was made to care,
 Don't Care was hung:
Don't Care was put in a pot
 And boiled till he was done.

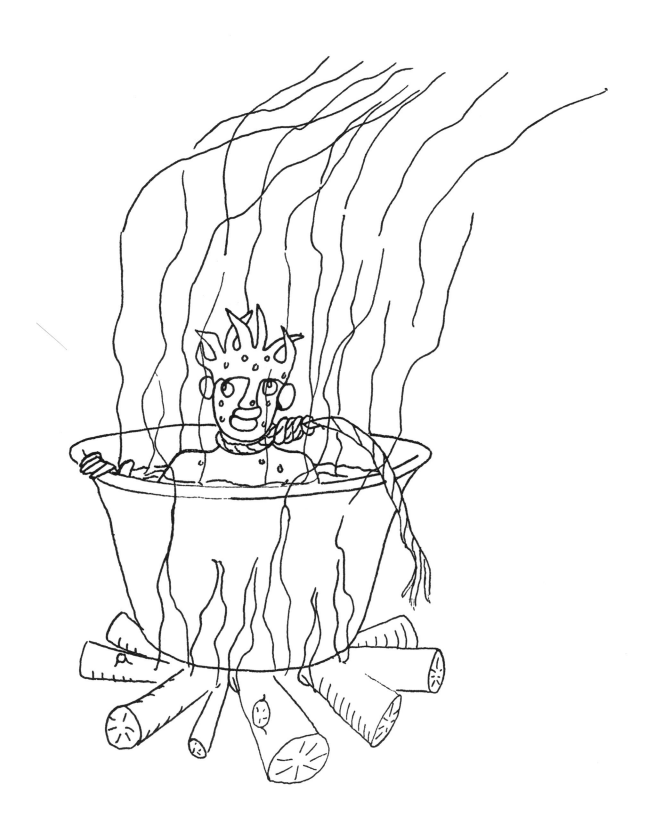

DOCTOR FAUSTUS was a good man,
He whipped his scholars now and then,
When he whipped them he made them dance
Out of Scotland into France,
Out of France into Spain,
Then he whipped them back again.

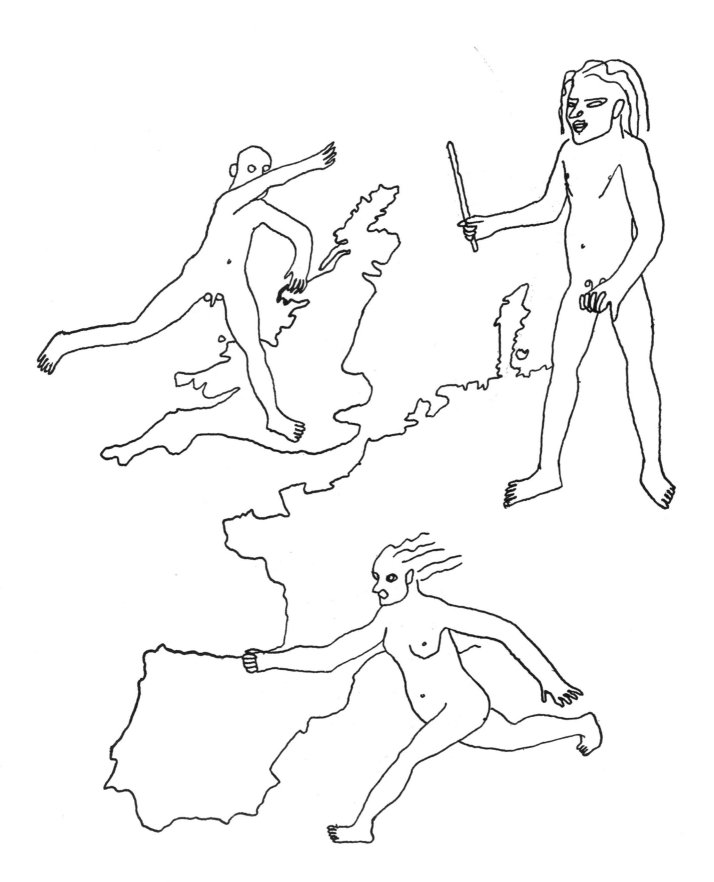

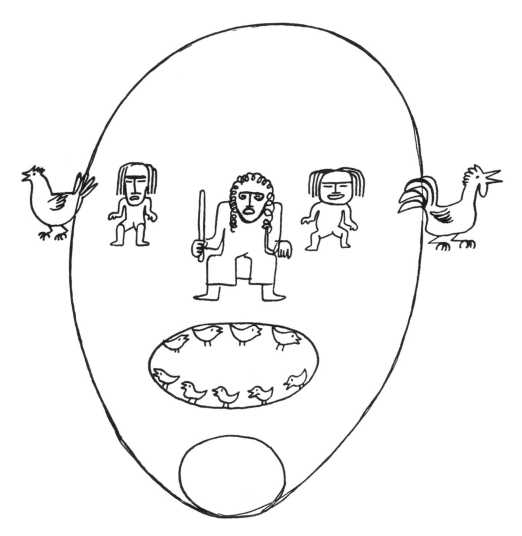

HERE sits the Lord-Mayor,
Here sit his men,
Here sits the cock,
Here sits the hen,
Here sit the little chickens,
Here they run in,
Chin-chopper, chin-chopper,
Chin-chopper, chin!

THE steed bit his master
How came this to pass?
He heard the good pastor
Cry, "All flesh is grass."

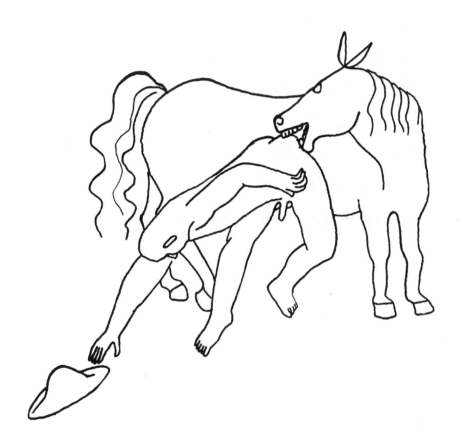

Solomon Grundy,
Born on Monday,
Christened on Tuesday,
Married on Wednesday,
Took ill on Thursday,
Worse on Friday,
Died on Saturday,
Buried on Sunday,
So that was the end of Solomon Grundy.

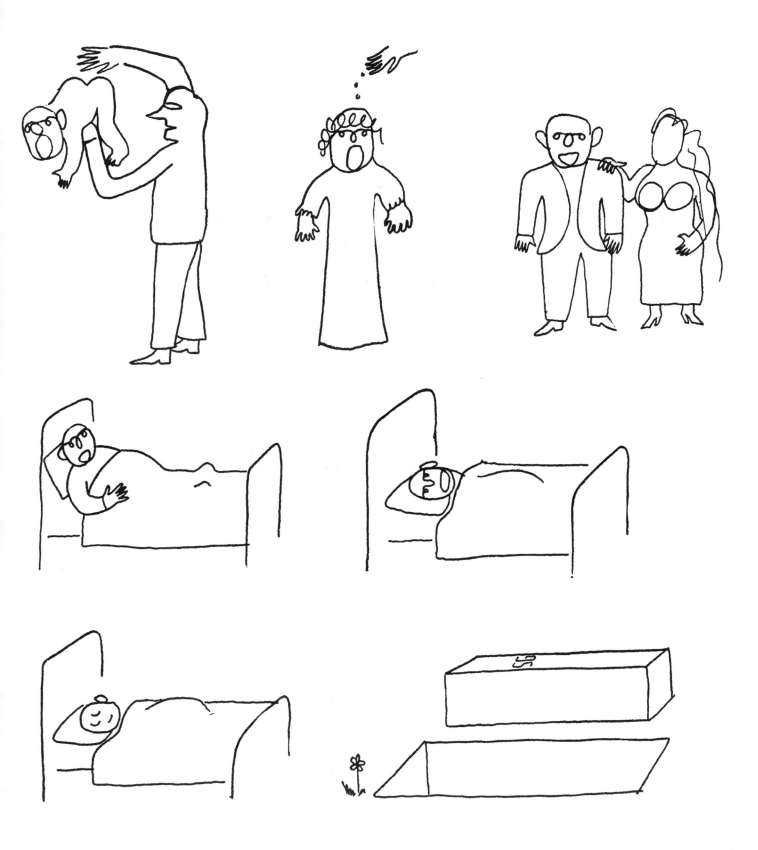

THERE was a man, and he had naught,
 And robbers came to rob him;
He crept up to the chimney pot,
 And then they thought they had him.

But he got down on t'other side,
 And then they could not find him;
He ran fourteen miles in fifteen days,
 And never look'd behind him.

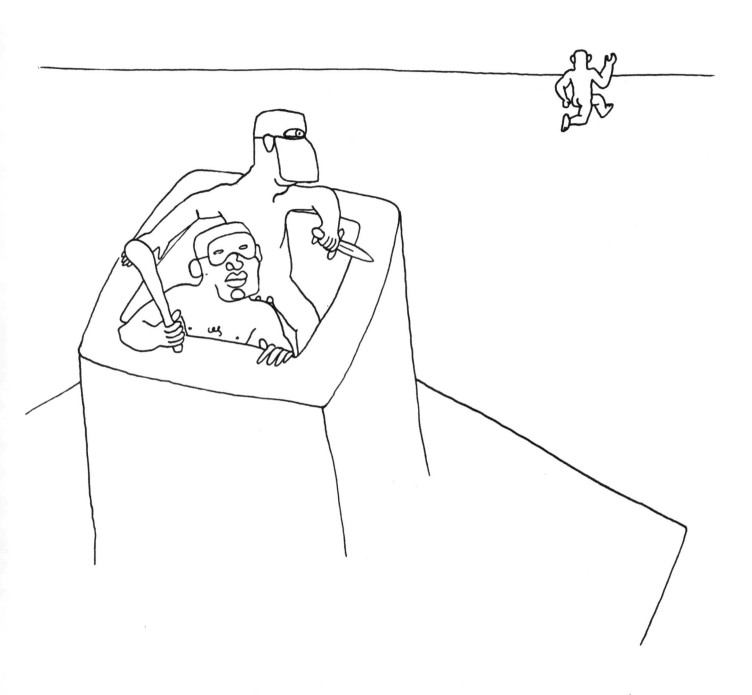

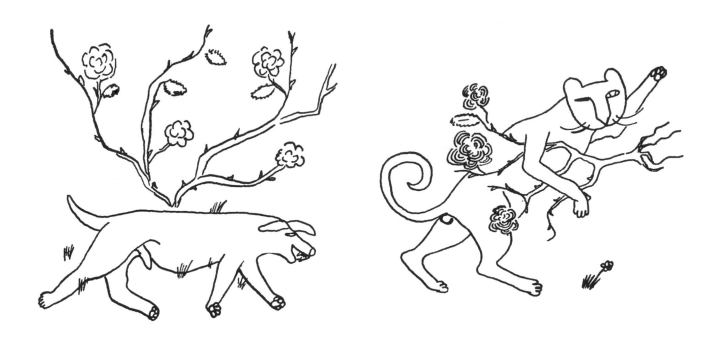

HUFF the talbot and our cat Tib
 They took up sword and shield,
Tib for the red rose, Huff for the white,
 To fight upon Bosworth field.

Oh, it was dreary that night to bury
 Those doughty warriors dead:
Under a white rose brave dog Huff,
 And fierce Tib under a red.

Low lay Huff and long may he lie!
 But our Tib took little harm:
He was up and away at dawn of day
 With the rose-bush under his arm.

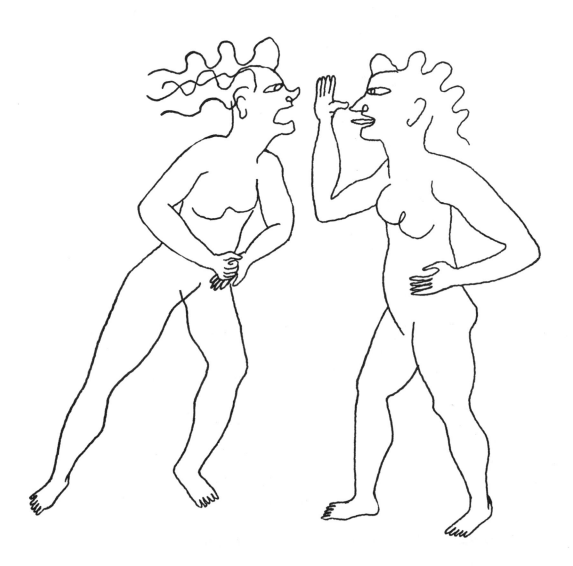

BETTY my sister and I fell out.
And what do you think it was all about?
She loved coffee and I loved tea,
And that is the reason we could not agree.

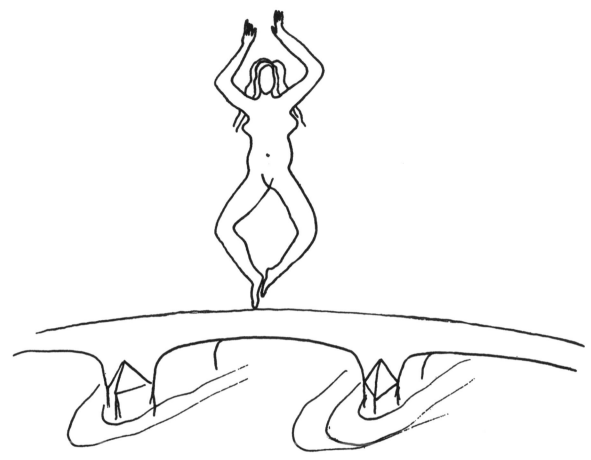

LONDON BRIDGE is broken down,
 Dance o'er my lady lee,
London Bridge is broken down,
 With a gay lady.

How shall we build it up again?
 Dance o'er my lady lee,
How shall we build it up again?
 With a gay lady.

Build it up with silver and gold,
 Dance o'er my lady lee,
Build it up with silver and gold,
 With a gay lady.

Silver and gold will be stole away,
 Dance o'er my lady lee,
Silver and gold will be stole away,
 With a gay lady.

Build it up with iron and steel,
 Dance o'er my lady lee,
Build it up with iron and steel,
 With a gay lady.

Iron and steel will bend and bow,
 Dance o'er my lady lee,
Iron and steel will bend and bow,
 With a gay lady.

Build it up with wood and clay,
 Dance o'er my lady lee,
Build it up with wood and clay,
 With a gay lady.

Wood and clay will wash away,
　　Dance o'er my lady lee,
Wood and clay will wash away,
　　With a gay lady.

Build it up with stone so strong,
　　Dance o'er my lady lee,
Huzza! 'twill last for ages long,
　　With a gay lady.

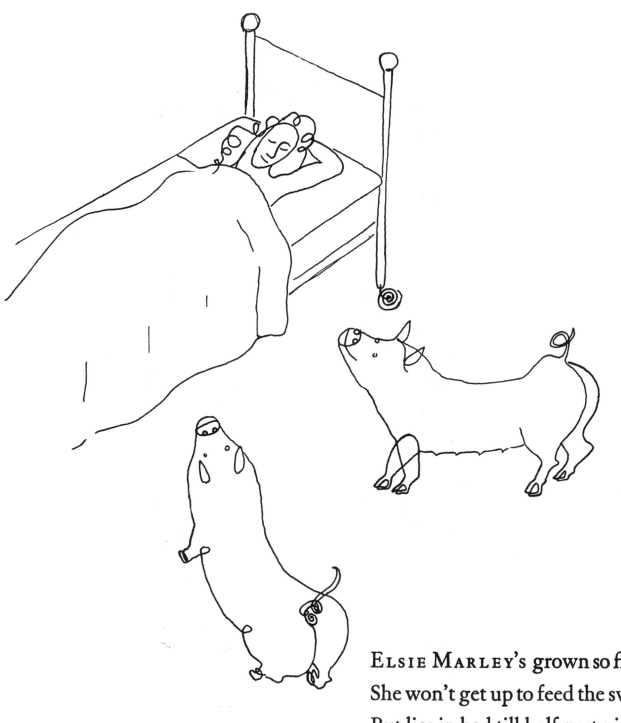

ELSIE MARLEY's grown so fine,
She won't get up to feed the swine,
But lies in bed till half-past nine,
Surely, she does take her time.

I'LL tell you a story of Jock o' Binnorie,
 And now my story's begun;
I'll tell you another of Jock and his brother,
 And now my story's done.

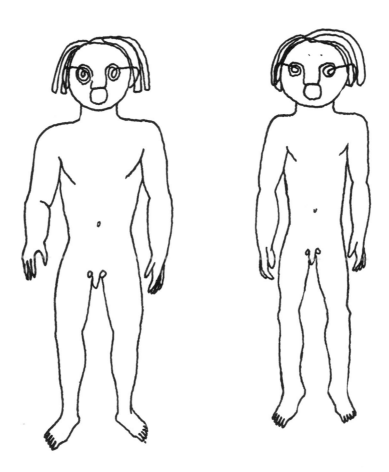

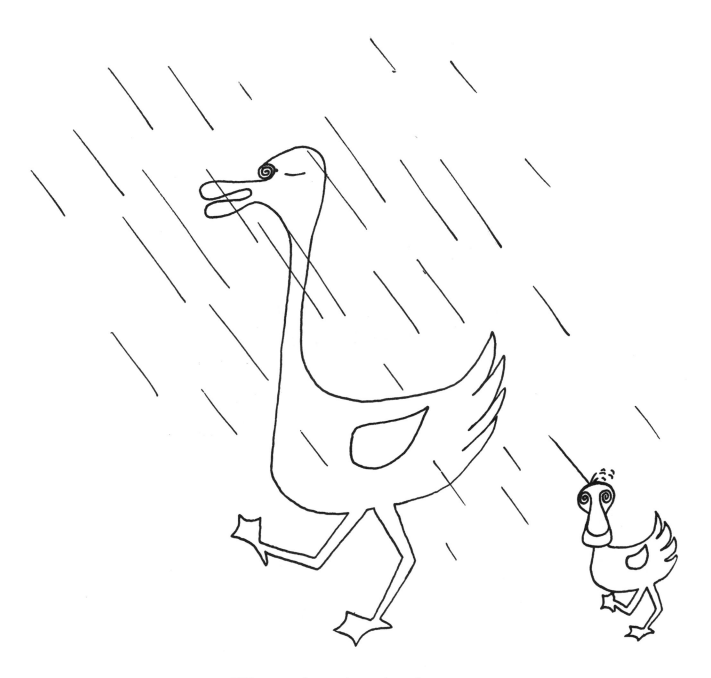

WHEN the rain raineth
 And the Goose winketh,
Little wotteth the Gosling
 What the Goose thinketh.

I WENT to Frankfort, and got drunk
With that most learn'd professor—Brunck:
I went to Worts, and got more drunken
With that more learn'd professor—Ruhncken.

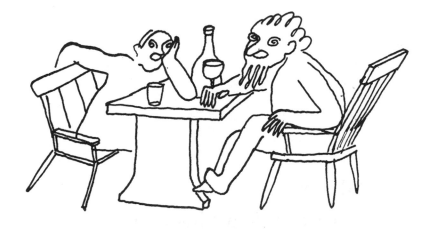

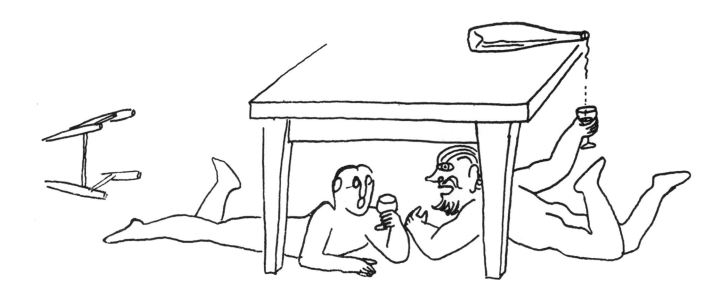

THERE was a man, a very untidy man,
 Whose fingers could nowhere be found to put in his tomb.
He had rolled his head far underneath the bed:
 He had left his legs and arms lying all over the room.

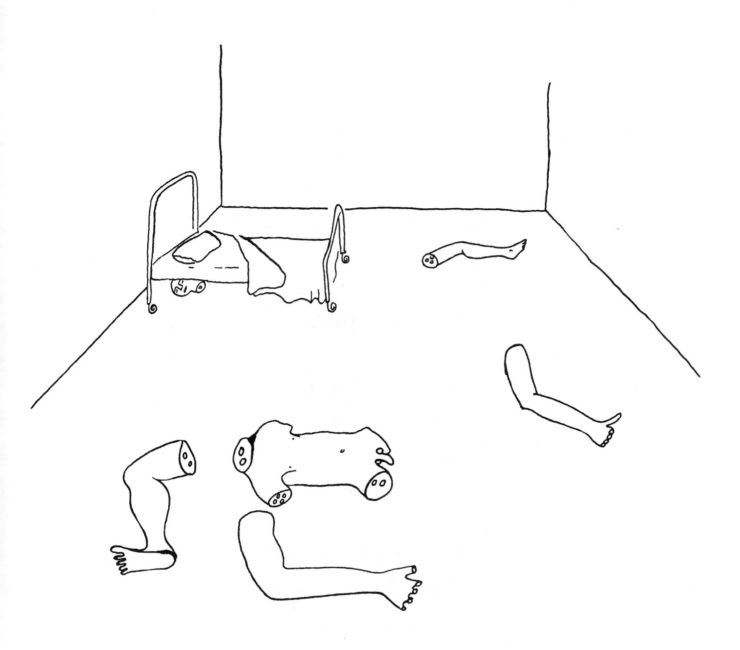

THERE was a king met a king
 In a narrow lane.
Says this king to that king,
 "Where have you been?"

"Oh, I've been a-hunting
 The buck and the doe."
"Pray lend a dog to me
 That I may do so."

"Take the dog *Greedy Guts*."
 "What's the dog's name?"
"I've told you already."
 "Pray tell me again."
"GREEDY GUTS!"

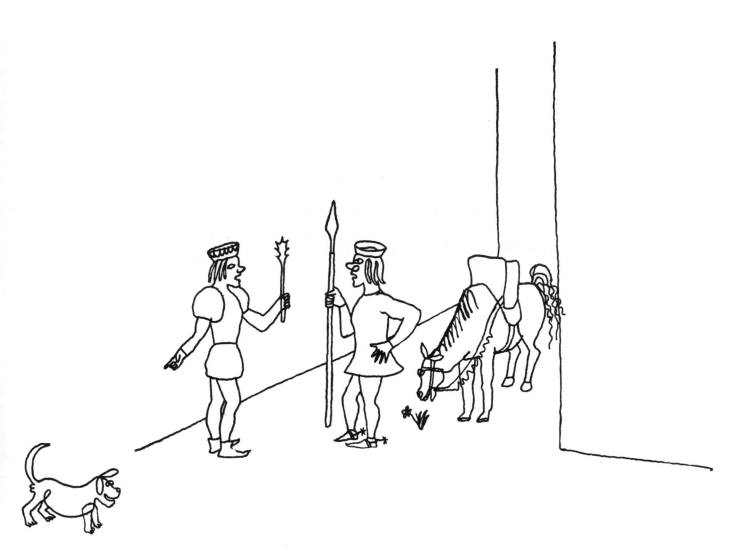

Tom tied a kettle to the tail of a cat,
Jill put a stone in the blind man's hat,
Bob threw his grandmother down the stairs—
And they all grew up ugly, and nobody cares.

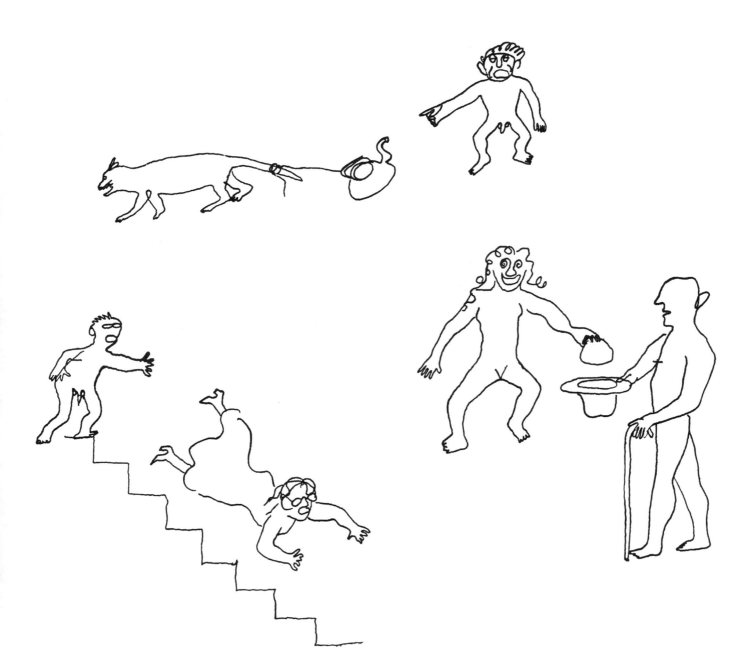

Lizzie Borden took an axe,
Hit her father forty whacks,
When she saw what she had done,
She hit her mother forty-one.

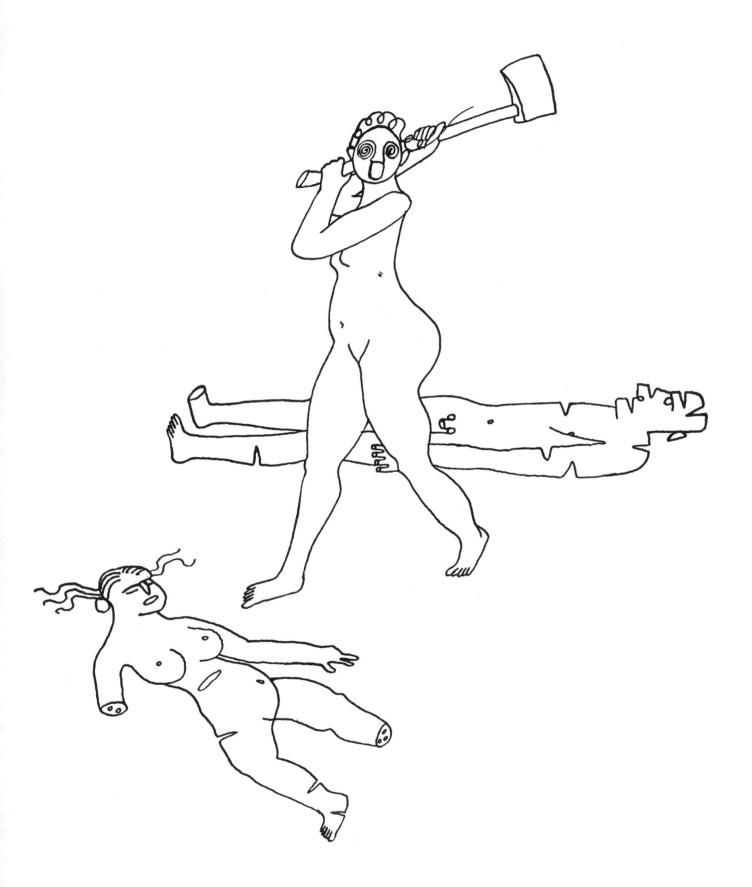

I'LL sing you twelve O

Green grow the rushes O

What are your twelve O?

Twelve for the twelve apostles

Eleven for the eleven that went up to heaven

Ten for the ten commandments

Nine for the nine bright shiners

Eight for the eight bold rainers

Seven for the seven stars in the sky

Six for the six proud walkers

Five for the symbol at your door

Four for the Gospel makers

Three, three for the rivals

Two, two for the lily-white boys

Clothed all in green – O

One is one and all alone

And evermore shall be so.

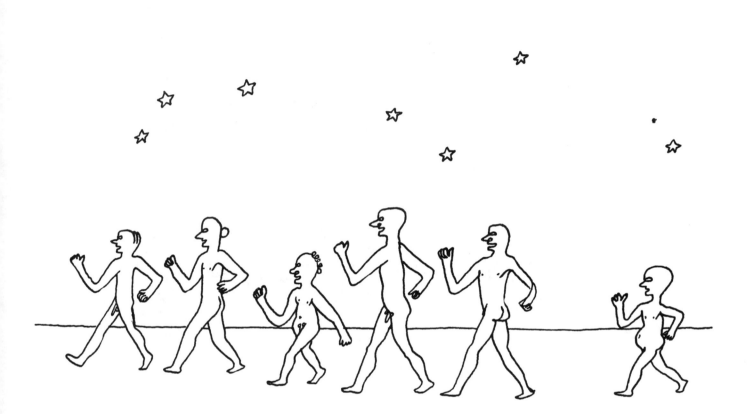

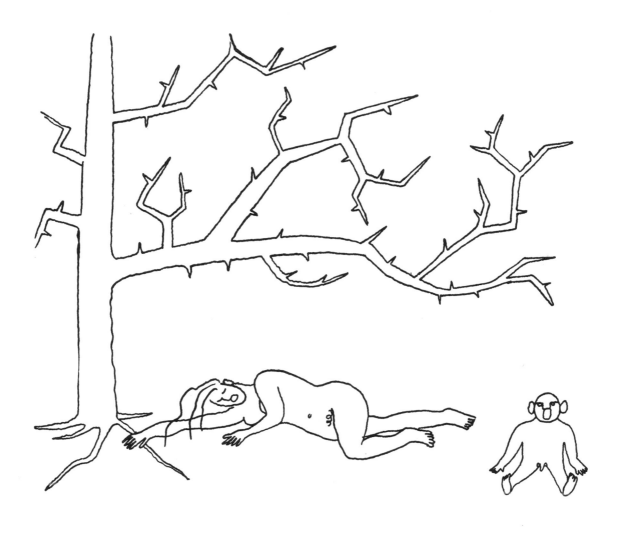

LITTLE lad, little lad,
Where wast thou born?
Far off in Lancashire
Under a thorn,
Where they sup sour milk
From a ram's horn.

Did you see my wife, did you see, did you see?
Did you see my wife looking for me?
She wears a straw bonnet with white ribbons on it,
And dimity petticoats over her knee.

THE winds they did blow,
 The leaves they did wag;
Along came a beggar boy
 And put me in his bag.

He took me up to London,
 A lady did me buy,
Put me in a silver cage,
 And hung me up on high.

With apples by the fire
 And nuts for to crack,
Besides a little feather bed
 To ease my little back.

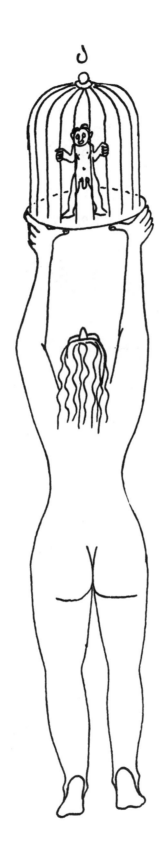

ONE, TWO,
 Buckle my shoe.
Three, Four,
 Open the door.
Five, Six,
 Pick up sticks.
Seven, Eight,
 Lay them straight.
Nine, Ten,
 A good fat hen.
Eleven, Twelve,
 Dig and delve.
Thirteen, Fourteen,
 Maids a-courting.
Fifteen, Sixteen,
 Maids in the kitchen.
Seventeen, Eighteen,
 Maids a-waiting.
Nineteen, Twenty,
 My plate's empty.
Please, mother, may I have
 another helping of pudding?

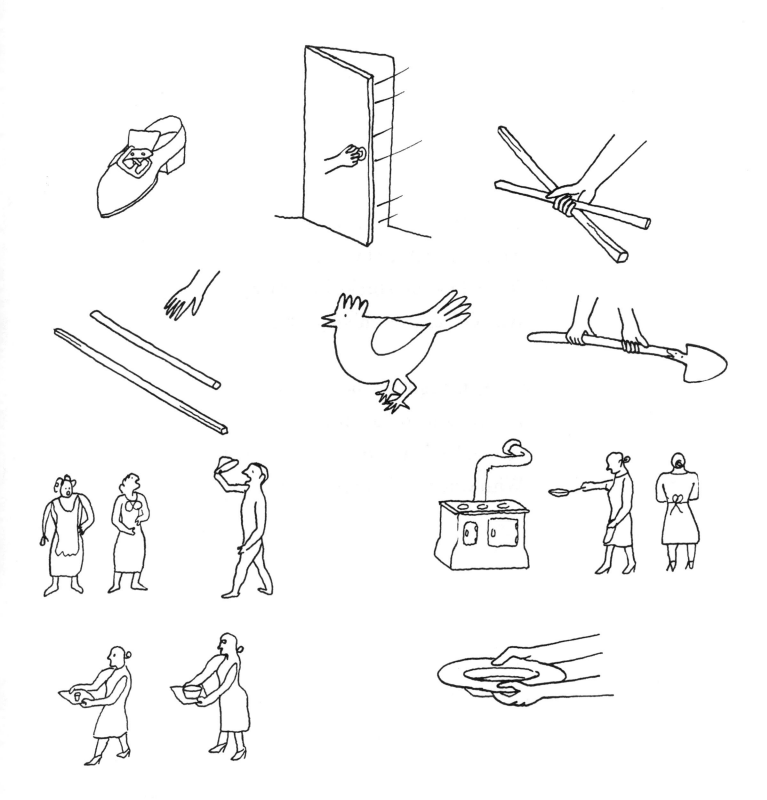

JACK and Gill went up the hill
 To fetch a bottle of water;
Jack fell down and broke his crown,
 And Gill came tumbling after.

Then up Jack got and home did trot,
 As fast as he could caper,
Dame Gill did the job to plaster his nob
 With vinegar and brown paper.

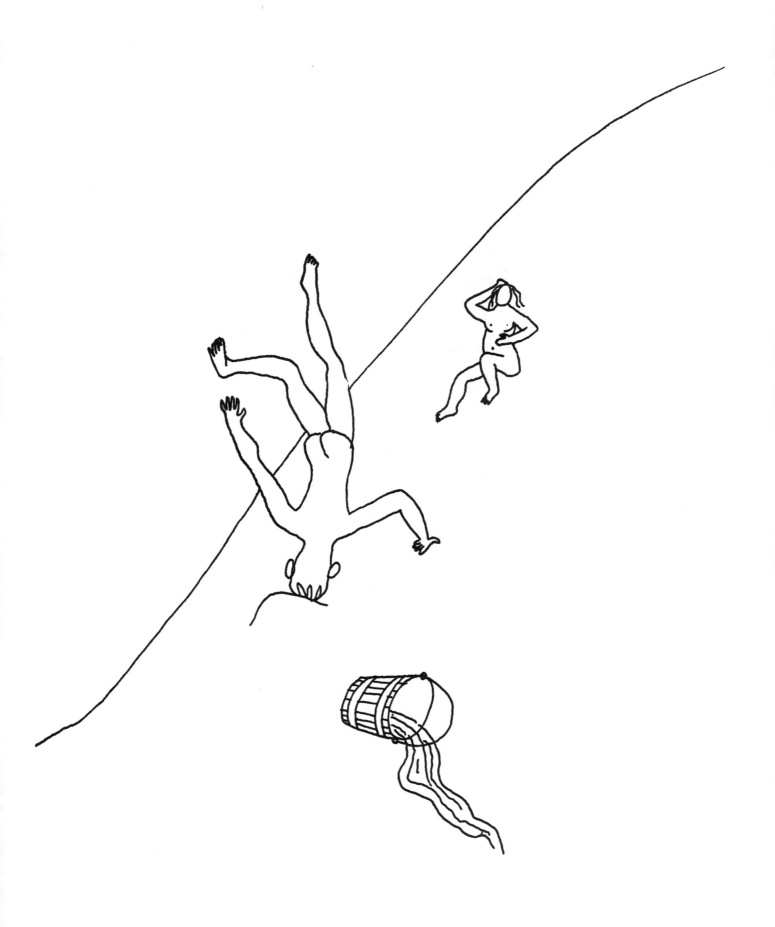

THERE was a crooked man
 Who walked a crooked mile,
He found a crooked sixpence
 Against a crooked stile.

He brought it crooked back
 To his crooked wife Joan,
And cut a crooked snippet
 From the crooked ham-bone.

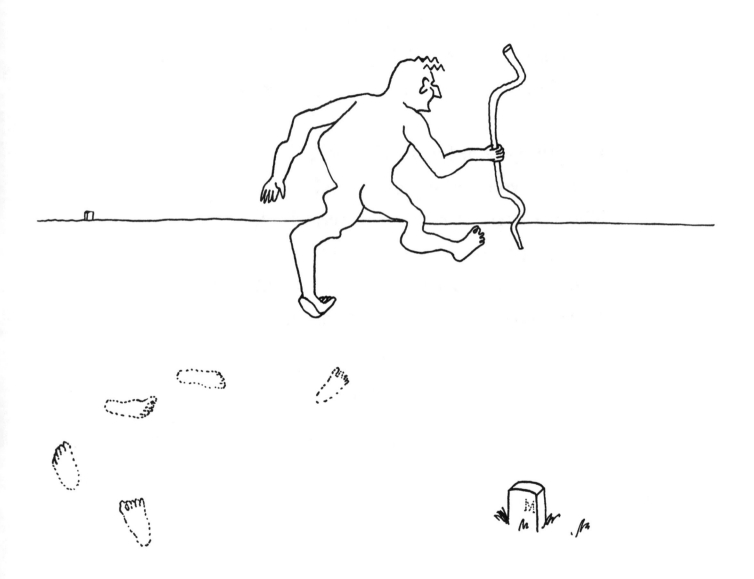

You never know as the hearse rolls by
When it may be your turn to die;
They wrap you up in a big white sheet,
And drop you down about sixty-five feet.
They throw in dirt, and they throw in rocks,
And they don't give a damn if they break the box.

Everything's fine for about a week,
And then your coffin begins to leak,
The worms crawl in, the worms crawl out,
They play pinochle on your snout,
They invite their friends, and their friends' friends too.
You look like hell when they're through with you.

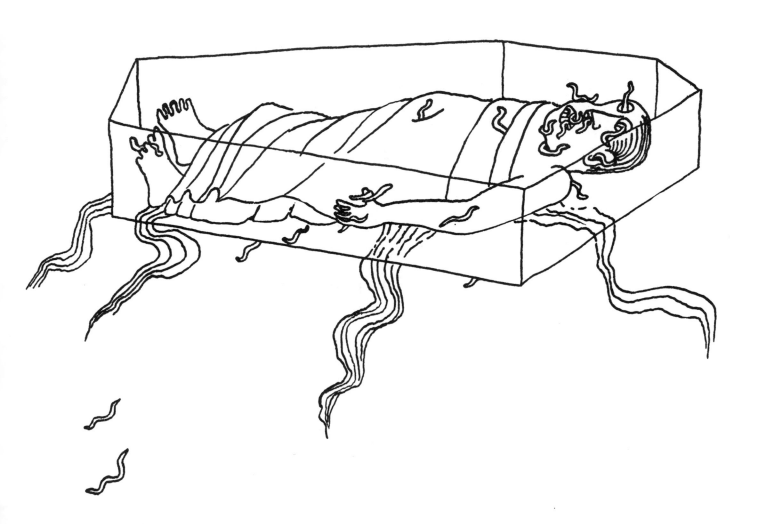

THE twelfth day of Christmas,
My true love gave me
Twelve lords a leaping,
Eleven ladies dancing,
Ten pipers piping,
Nine drummers drumming,
Eight maids a milking,
Seven swans a swimming,
Six geese a laying,
Five gold rings,
Four colly birds,
Three French hens,
Two turtle doves, and
A partridge in a pear-tree.

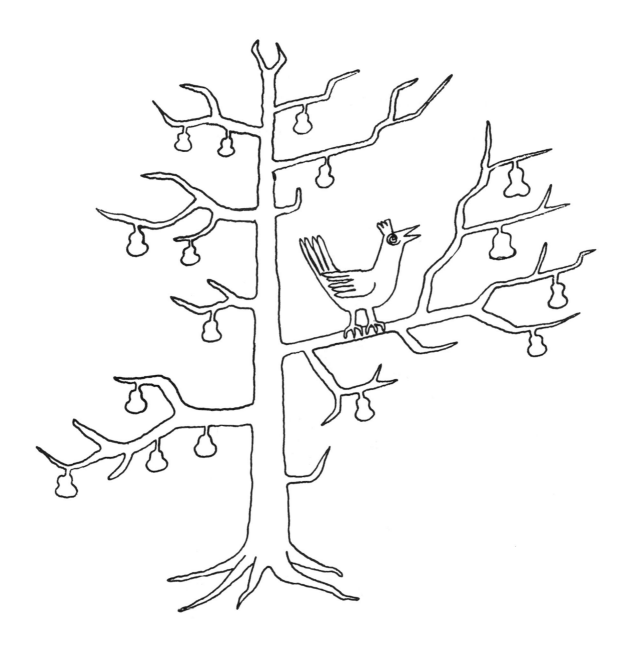

I AM His Highness' dog at Kew;
Pray tell me, sir, whose dog are you?

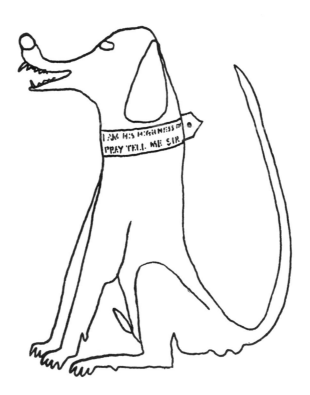

Index of First Lines